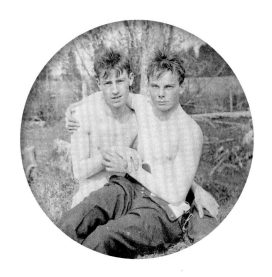

Len&Cub

A QUEER HISTORY

MEREDITH J. BATT and DUSTY GREEN

GOOSE LANE

Edited by Simon Thibault.
All images courtesy of the Provincial Archives of New Brunswick unless otherwise indicated.
Cover and page design by Julie Scriver.
Front cover: Len and Cub at the Keith family cabin at Cranberry Lake, New Brunswick (P27-MS1O1-140).
Back cover: Len and Cub on an excursion to Jemseg, c. 1916. Image colourized by Jules Keenan. (P27-MS1O1-172)
Printed in Canada by Friesens.
10 9 8 7 6 5 4 3 2

Library and Archives Canada Cataloguing in Publication

Title: Len & Cub : a queer history / Meredith J. Batt and Dusty Green.
Other titles: Len and Cub
Names: Batt, Meredith J., author. | Green, Dusty, author.
Description: Includes bibliographical references.
Identifiers: Canadiana (print) 20210363894 | Canadiana (ebook) 20210363967 | ISBN 9781773102641 (softcover) | ISBN 9781773102658 (EPUB)
Subjects: LCSH: Keith, Leonard. | LCSH: Coates, Joseph (Of Havelock) | LCSH: Gay couples—New Brunswick—Biography. | LCSH: Gay men—New Brunswick—Biography. | LCSH: Gay men—New Brunswick— Pictorial works. | LCGFT: Biographies.
Classification: LCC HQ75.7 .B39 2022 | DDC 306.76/6209227151—dc23

Goose Lane Editions acknowledges the generous support of the Government of Canada, the Canada Council for the Arts, and the Government of New Brunswick.

Goose Lane Editions
500 Beaverbrook Court, Suite 330
Fredericton, New Brunswick
CANADA E3B 5X4
gooselane.com

For the queer youth of New Brunswick,
may you take heart from this story and find your place in this province.

And in memory of our wonderful friend and mentor,
who encouraged us to tell this tale, R.M. Vaughan (1965-2020).

And to Leonard Olive Keith and Joseph Austin Coates,
without whom this book would not be possible.

Contents

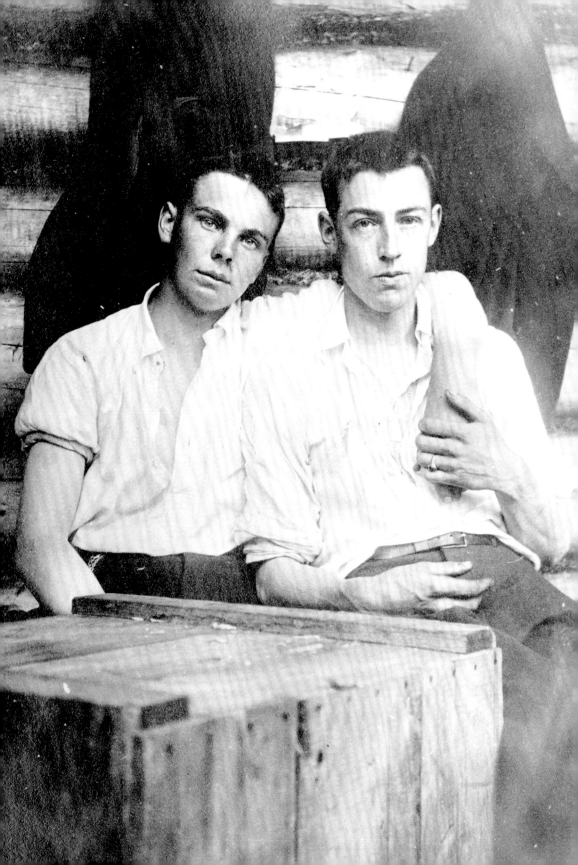

Preface

DUSTY GREEN

While working on this book, Meredith and I were often asked what it meant to us to bring Len and Cub's story to light. We've regularly remarked that we see ourselves in Len and Cub, that we relate to them in many ways, even going so far as to refer to them as "our boys." What I didn't anticipate was how our boys would empower me, let alone the empowerment that came with representation. I don't think either one of us realized how important this story would be for us, and what it could mean for other queer people in the province and indeed all New Brunswickers. With the photos of Len and Cub, this identifiably queer couple from rural New Brunswick from nearly a century ago, I not only got to see them but myself as well.

Growing up in rural New Brunswick during the 1990s and early aughts, queer representation was extremely limited, especially where I needed it most: in my school life and in the curriculum. I was never taught about queer people or sexuality. There was no mention of queer liberation in history or social studies, and the less said about my exclusively heterosexual abstinence-centric sex-ed, the better. To say that growing up queer in rural New Brunswick was difficult for me is to put it mildly.

Over time I became aware of the often-touted phrase in queer circles, "We have always been here." I knew that *we, queer people*, had always existed, but the *here* never clicked for me. Growing up, the word "gay" was exclusively used as a slur, and by the time I came out at sixteen, I had developed an internalized homophobia that was so firmly set that I considered it to be baked-in. Being gay was the last thing I wanted to be after hearing and absorbing all of the horrible things that my adolescence had supposedly taught me about what it meant to be gay. Its fuel source came in the form of derision from my peers, my church, and the community at large, culminating in an act of homophobic violence that marked the end of my time living in rural New Brunswick. Belonging to a marginalized population in a place seemingly devoid of representation, where physical violence was no longer a threat but a reality, compounded my sense of being ostracized.

I still carry the weight of that trauma, but things feel lighter now. Part of bringing that lightness to fruition involved embracing queer culture, identity, and history as a form of healing. Despite being separated by some hundred years or so, throughout the course of writing this book I found myself relating more and more to Len and Cub's experiences as outsiders, queer people surviving a volatile environment in their own hometown. Their lives resonated with me as I recognized their ability to hide in plain sight. I caught myself imagining the boys finding safe spaces to express themselves, and perhaps developing their own system of coded language in order to keep their relationship (and themselves) safe.

Despite working in the culture and heritage sector during and after university, queer history seemed to elude me. It was missing from my education and suspiciously absent in institutions. With no apparent evidence to the contrary, I assumed that queer records from the past were either extremely rare or simply did not exist. What little queer history I knew about came strictly from urban areas far away from my hometown: the Stonewall Riots of 1969 in New York City or Operation Soap, when the bathhouses were raided by police in Toronto in 1981. Our history was one of fighting the violence against us, rising up against it. Where were the stories of queer resistance, activism, and liberation from my province? Queer history in New Brunswick? Impossible, I thought. Not in my vision of this place.

While I was working at the Provincial Archives of New Brunswick (PANB) in 2015, a photo album belonging to John Muir McKinlay, a Canadian First World War photographer, was donated. Among McKinlay's hundreds of photos, commissioned by the Canadian government to show that prisoners were being well treated, were a few dozen snapshots taken at the Amherst Internment Camp in Nova Scotia (1917-

1919). At the time, the camp was the largest in the country, with some eight hundred German prisoners of war,[1] many of whom formed clubs based on their interests such as weightlifting, gardening, and theatre. Most of the snapshots of the all-male theatrical troupes at the Amherst Camp include photos of men in drag. Some of the photos show just one or two men in drag, while others show upwards of a dozen men in matching dresses and makeshift wigs, posed in chorus lines.

My understanding of sex and gender expression during this era was challenged by these photos, let alone my knowledge of Canadian First World War internment camps and the lives of their prisoners. Enamoured by McKinlay's album, I asked around the archives to see if there were any other examples of records that might relate to the history of sex and gender expression in Canada. Textual government records existed of course, documenting legal cases and internal municipal matters related to LGBT history, but results were scanty until PANB archivist Julia Thompson pointed me in the direction of a collection that she had accessioned in 2011, P27: The John Corey Collection. Julia recalled that the records included photos of a same-sex couple from the small town of Havelock, New Brunswick, whom the donor, John Corey, had described as boyfriends when donating the records. The collection is a large assortment of photos, prints, albums, and glass negatives that document the town of Havelock between the late nineteenth century and the first half of the twentieth century. The bulk of these records focus on a number of family names you will still find in Kings County today, with special attention to the Keith family, as well as the Coreys and Prices. The boyfriends in question were Leonard Olive Keith (1891-1950) and Joseph Austin Coates (1899-1965), affectionately known in town as "Len" and "Cub." Len was an avid amateur photographer who spent a substantial amount of time experimenting with his camera as he documented the world around him.

By the turn of the century, photography in Canada had undergone considerable advancements in technology and accessibility, with less expensive and easily operated cameras, as well as mail service for developing images. These changes opened the craft to a new group of amateur photographers. Before this, photography had been too expensive, complicated, and cumbersome for the average person, let alone a youth like Len, to take on as a hobby. When the Keith family purchased their camera around 1905, Kodak had launched its popular and accessible line of folding cameras, causing an explosion in the number of amateur photographers operating across North America[2]—including fifteen-year-old Len. Albums belonging to his siblings show that members of the Keith family took advantage of this form

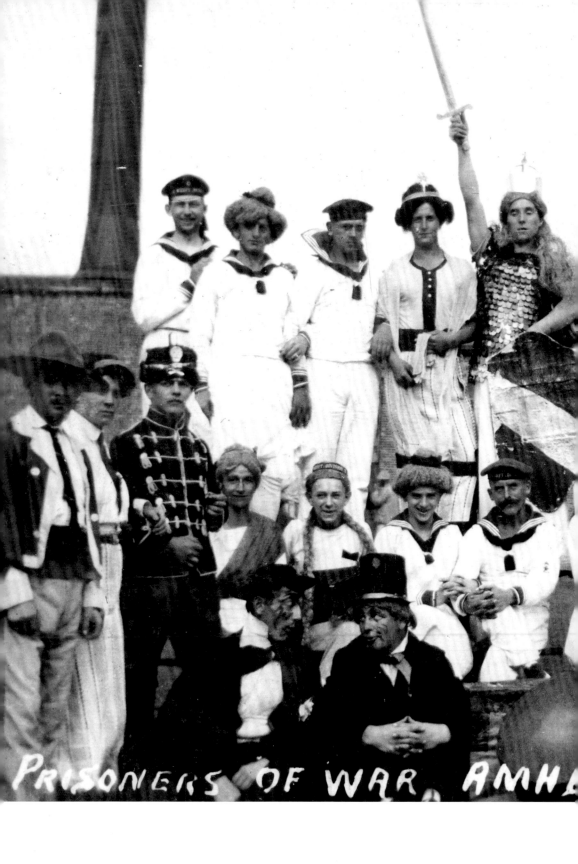

PRISONERS OF WAR AMHE

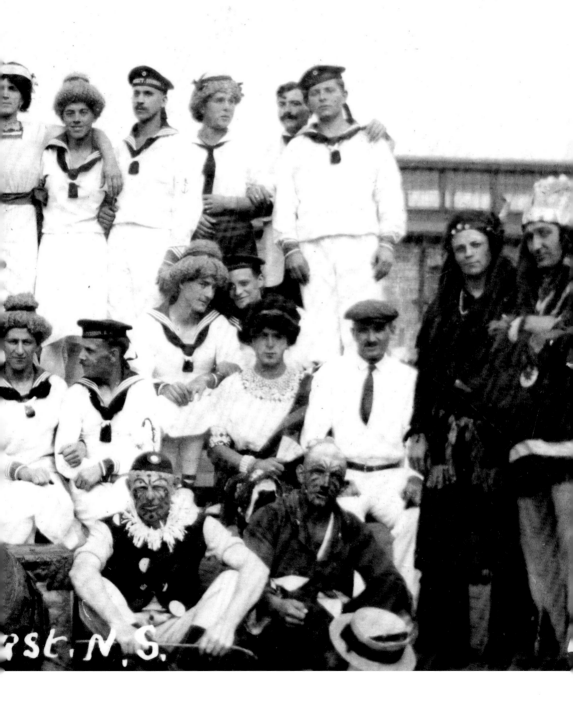

A photograph by John Muir McKinlay of a theatre troupe composed of prisoners of war, including many men in drag, Amherst, Nova Scotia, c. 1917. (P827-MS1-153)

of candid and less formal photography. However, none took it as seriously as Len did, as his photos make up the lion's share of the family's archival records. Len dedicated time to learning about and experimenting with photography. Some of his photos, such as the many candid, blurry shots of his friends and family, make it clear he was an amateur, but Len also cared about the art of photography. He worked at improving the quality of his snapshots to create artistically considered landscapes and carefully orchestrated portraits. His passion for the art and science of photography is found everywhere from his experiments with exposures to his attention to composition, which extended to arranging the labels on canned goods, liquor, and tobacco to face the camera.

Len's photos feature Cub more than anyone else. These images make it clear that the two shared a special bond, one that started early and continued through their formative years until Len was eventually driven out of town for being a homosexual. They spent a lot of time together enjoying the wilds that surround Havelock; going on drives in Len's family car, taking hunting trips, and seeming to find any excuse they could to be alone together. Their affections are clear, and their story remains arguably the oldest known photographic record of a same-sex couple in New Brunswick or in the Maritimes.

My exposure to the McKinlay album, and Len's collection of photos in the John Corey collection, led to a desire to seek out more records like this. In 2016 I established the Queer Heritage Initiative of New Brunswick (QHINB), a community archival project dedicated to the collection and preservation of 2SLGBTQ+ records in the province. Today, in partnership with the Provincial Archives of New Brunswick, QHINB continues to collect and preserve these records and provide public education opportunities to learn about the queer history of New Brunswick. It was important to me that people have a better idea of what life was like for 2SLGBTQ+ New Brunswickers in the past, and that we develop some semblance of a queer history of this place. During a research trip to the ArQuives in Toronto, Canada's largest 2SLGBTQ+ archive, I showed Len's photos to Alan Miller, a librarian and longtime volunteer with the organization. He suggested that Len and Cub would make important subjects for a book, rightfully noting that such a rare example of a same-sex couple living at the turn of the century in such a rural location was too exceptional not to share with the world. I agreed.

The story of Len and Cub provides, for me, a clear and permanent record of a queer relationship existing despite the hostile time and environment in which the couple lived. Having this evidence and exploring their lives has given credence to

the statement that *we have always been here. Here* includes not just Toronto but the furthest of back roads in the most rural and forgotten-about places. Places queer people are told they don't belong. Len and Cub's lives were no doubt difficult at times, but the record of their lives is a testament to the resilience of queer people and an affirmation that we belong in any place we choose to call home.

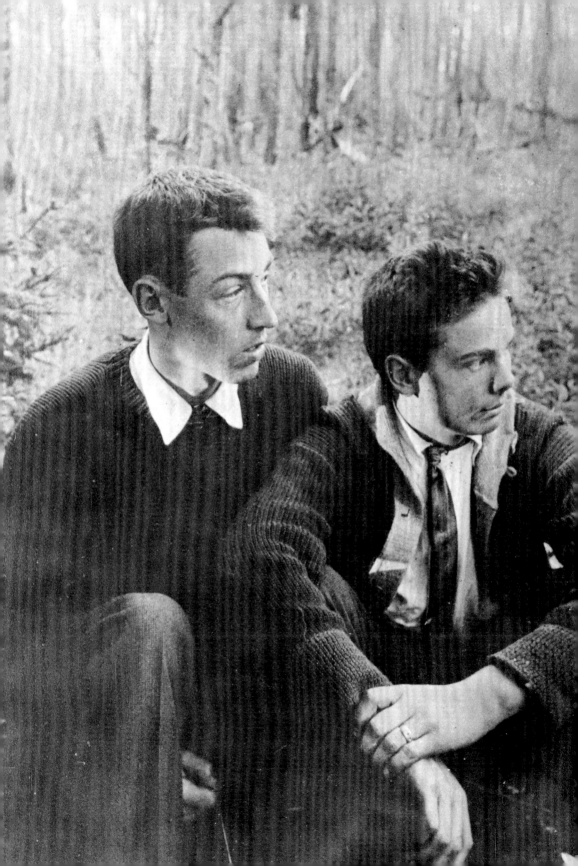

Finding Len & Cub

Leonard Olive Keith and Joseph Austin "Cub" Coates were both born in the rural community of Butternut Ridge (known today as Havelock), New Brunswick, at the end of the nineteenth century. Len was an amateur photographer and automobile enthusiast who went on to own a local garage and pool hall after serving in the First World War. Cub was the son of a farmer, a veteran of the First and Second World Wars, a butcher, a contractor, and a lover of horses. The two were neighbours and developed a close and intimate relationship with each other.

Len and Cub's time together is documented by the many photos taken by Len, showing that the two shared a mutual love of the outdoors, animals, alcohol, and adventure. As many amateur photographers do, Len photographed what was important to him, and Cub's prevalence among the hundreds of photos is striking and impossible to ignore. The photos taken in the 1910s and 1920s show the development of their relationship as Len and Cub explore the wilderness of Havelock and spend time alone together. Unfortunately, these adventures would cease when Len was outed as a homosexual by community members in the early 1930s and forced to leave Havelock. Cub, however, remained seemingly untainted by scandal and stayed in Havelock until 1940,

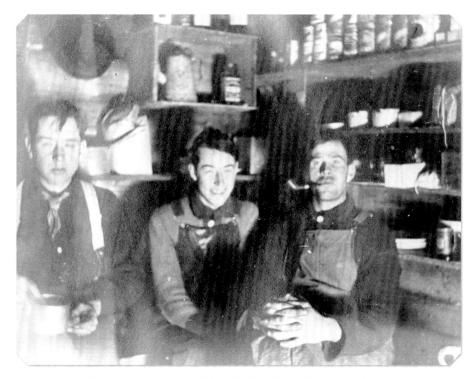

Frank Austin Keith, Len, and Roy Manford Corey (John Corey's father).
(P27-MS1-O-75)

when he married Rita Cameron, a nurse born in Chatham, and relocated to Moncton after the Second World War. He would go on to become a prominent figure in New Brunswick's harness racing circles before his death in 1965. Len never returned to Havelock, residing near Montreal before succumbing to cancer in 1950.

Len's photos were donated to the Provincial Archives of New Brunswick decades after his death by Havelock resident and local historian John Corey, who had purchased the albums at the Keith family's estate sale in 1984. Growing up, John heard stories of Len and Cub from his father, Roy Manford Corey, who had been a classmate of Len's. When John donated the albums in 2011, he described the pair as "boyfriends"—a term noted by the archivist in the collection's finding aid. The archivist also noted, after a conversation with John, that Len had been "driven out of town for being a homosexual" by a group of Havelock men. This anecdote is written on an envelope containing a photo of one of the men responsible for Len's outing.

John Corey's assertion that Len and Cub were indeed "boyfriends" is supported by the many photos of the two men together, holding hands or lying in bed. They displayed a level of kinship and affection that confutes the likelihood of them being *just* close friends. The photos had existed in the archives for some time but had never been interpreted as an example of queer history. By observing Len's photos through a queer lens, we were able to remark on subtle and not-so-subtle cues in the photos—the compositions and settings, the subjects' poses, their garb and demeanour—in order to glean evidence as to how a same-sex relationship may have been able to exist in this time and place.

In viewing this collection, we saw our opportunity as well as our responsibility as archivists, community historians, and queer people to share Len's photos and bring Len and Cub's story to light. Their time together captures one of the earliest known queer stories in New Brunswick's history. It is a tale of great pain and loss but, more importantly, one of love, friendship, and coming of age.

We saw the importance of portraying these images in an unaltered state, presenting them as they were, to give viewers an opportunity to uncover a relationship that otherwise may have been forgotten, ignored, or destroyed. As queer people, we recognized the importance of these photos, which provide definitive proof that we have always been here, even in rural New Brunswick in the early twentieth century. To respect those perspectives and motivations, we knew we had to do more than just present the images, relate the anecdotes, and leave it at that. We needed to tell the story and give it its due diligence in terms of research.

We began to research primary source documents relating to Len and Cub to build a timeline of their lives. These records allowed us to corroborate dates and events, while we scoured the photos for evidence of Len and Cub's relationship. For example, we learned that after Len returned from Tilton School around 1915 to 1916, Len and Cub started spending a lot of time with each other, as evidenced by the large number of photos of them together during this time period. We also know that they travelled to Saint-Jean-sur-Richelieu, Quebec, for military training together and went to war in 1918, returning to Havelock in 1919. Beyond the historical and public records that helped us pinpoint the timeline of the relationship, we also used the record of the photographs themselves as an indicator of the trajectory of their lives. Over time, Cub appears less frequently in the images. By the late 1920s, Cub rarely appears, and he is almost completely absent in the period leading up to Len's outing and expulsion from Havelock in 1931.

This book chronicles Len and Cub's lives together. In order to properly frame their story, we did not rely only on public and private records. We also knew it was important to discuss and present to our readers the history of queer experiences in rural places; the nature and roles of sex, gender, and sexuality in early twentieth century North America; and the significance of homosocial spaces and relationships,[1] as well as the relationship between homophobia and the law. We used these tools in interpreting and divining how a queer couple like Len and Cub would have been able to exist in rural New Brunswick during the early part of the twentieth century.

We knew it was up to us—as New Brunswickers, as archivists, as queer people—to glean as much as we could from these photos, to give readers (and viewers) as much context as we could so that as many people as possible could understand Len and Cub, their lives, and how their relationship existed in the manner it did.

Languages of Desire

Before talking about Len and Cub, we have to define *how* we talk about homosexuality, past and present. The language we use to talk about same-sex desire today is the result of a long and complex history of terminology being invented and reinvented to meet the specific needs of those who wanted to discuss it. From the invention of the word *homosexual* to the reclamation of the word *queer*, different communities and cultures have used various signifiers to present and portray same-sex desire.

With respect to the communities and individuals we will be speaking of—which we, the authors, are a part of—different acronyms will be used in reference to the queer community. The language surrounding queer people, their sexual orientation, and gender identity is constantly evolving to include various sexual minorities. It is important to note that the acronyms used also reflect the identifying terms for sexual and gender minorities *as they existed* during various time periods, from LGB (Lesbian, Gay, Bisexual) to LGBT (Lesbian, Gay, Bisexual, and Transgender) to our contemporary 2SLGBTQ+ acronym (Two-Spirit, Lesbian, Gay, Bisexual, Transgender, Queer/Questioning, and others).[1]

By today's standards the word *homosexual* is viewed by many as a crude and antiquated term. During Len and Cub's

lives, however, it would have been used by many sexologists and psychologists. We also rely on a number of contemporary terms such as *queer* to help fill in the gaps where the language of the past is inadequately nuanced and often unnecessarily moralizing.

Over the last century and a half, queer human rights and public visibility have made monumental strides forward and encountered significant pitfalls. The work of early sexologists and human rights activists helped to develop language that described queer experiences without moralizing or pathologizing people living with queer desires. The term *homosexuality* was first used in 1869 by writer Karl Maria Kertbeny in a pamphlet sent to German ministers who were drafting a new penal code for the North German Confederation.[2] Kertbeny argued that private, consensual sex between people of the same sex should not be criminalized and that the law unjustly punished homosexuals, leaving them vulnerable to extortion and blackmail.[3] Although Kertbeny's understanding of same-sex desire led him to create his new word for legal purposes, specifically human rights reform, the term *homosexuality* would later be adopted by medical establishments as a means of classifying people and pathologizing their desires.

The roots that link queer sex with crime and sin are ancient and, in many ways, are still alive and well today in legal and societal spheres across the world. The term *sodomy* was used to describe what were viewed as "unnatural" sex acts, essentially any acts that could not result in procreation. Masturbation, oral sex, bestiality, and anal intercourse with someone of either the same or opposite sex were equally viewed as acts of sodomy. The English term *buggery* is a synonym for sodomy, used in a legal context to criminalize "unnatural" or "immoral" sex. The words were used interchangeably as moralizing descriptors and as legal jargon to police sex and desire, punishing deviation from what was viewed as the norm. The definitions of these terms were left open to interpretation, the effect of which was a widespread subjugation of same-sex desire.

As a British colony, the Province of Canada (now Ontario and Quebec) prohibited buggery under punishment of death until 1865, when it was reduced to a sentence of life in prison.[4] Although in pre-Confederation Canada there is little evidence to suggest that anyone was ever executed for buggery, the existence of an institutional threat of death or life imprisonment shows the extent to which Canadian society was willing to exert a strict Christian morality. This link between queer sex, sin, and crime continues to impact laws across the globe to this day as

homophobic and antiquated legal precedents continue to be used by religious leaders and states to obstruct contemporary human rights standards.

The earliest documentation of a case of conviction for attempted sodomy in New Brunswick can be found at the Provincial Archives and at the New Brunswick Museum. A petition on behalf of John Middleton Smith, a Saint John resident, and other citizens requesting Smith's banishment from the colony was sent to the colonial administrator in 1806, the result of a scandal that shook the Loyalist city to its core. Smith, an Anglican lay preacher and schoolmaster, arrived in Saint John around 1805, where he enjoyed a rather privileged position and befriended influential community members. It seems that he became entangled with a number of young men, some of whom Smith tried to seduce, and several of these incidents were reported to the colonial administrator. During this period, New Brunswick was a British North American colony and was subject to British law, which criminalized sodomy under punishment of death.[5] In the end, Smith was only charged with two incidents of attempted sodomy and sentenced to three months in jail and a fine of five pounds. Smith was also made to stand in the public pillory for half an hour for each offence, enduring the jeers and harassment of the passing crowds. To avoid further harassment, Smith petitioned to be banished from the colony, which high-ranking community members saw fit to grant in order to avoid being reminded of the scandal.

The Smith case is extremely important not only for what it reveals about same-sex experiences but also for what it suggests about gender presentation in early nineteenth-century British North America. In addition to the scandalous nature of this case, another element of intrigue during the trial was the speculation that Smith was a woman disguised as a man. One man testified that Smith had tried to convince him he was actually a woman and that "he could give him as much satisfaction as any woman."[6] There were enough testimonials and rumours swirling to this effect that Smith was forced to undergo a medical examination by local physicians, who declared that he did in fact have male genitalia. While our language to describe gender-variant individuals has evolved in the last few decades, it is possible that Smith may have chosen to identify as what we now refer to as genderfluid/non-binary or trans. Aaron Devor, the Chair in Transgender Studies at the University of Victoria, notes that to be openly gender-variant in the past was extremely dangerous.[7] We can conclude, based on the evidence, that while Smith publicly presented as a man, he may have discreetly displayed feminine

characteristics and attire to signal his willingness for intimacy with male suitors. Desire is a language that knows few bounds.

Throughout history criminal charges of sodomy and buggery have been difficult to prove, as they require evidence that penetration and ejaculation have occurred.[8] By 1892, the buggery law had proven so ineffectual that the crimes of *gross indecency* and *indecent assault* were adopted in order "to 'correct' a shortcoming in common law, which did not criminalize homosexual acts such as fellatio and mutual masturbation."[9] The language used to pursue gross indecency charges avoided mentioning specific acts, which left it open to interpretation on a case-by-case basis, but it was understood by police and lawyers to be a means of criminalizing homosexual sex and affection and would not be repealed until 1985.[10] Two men kissing would not have been considered buggery, but it could have been considered gross indecency.

This sentiment against homosexuality persisted. By the mid-1950s and the Cold War era, homosexuals in Canada were often viewed as untrustworthy and unpatriotic due to their susceptibility to blackmail. This fear led to the federal government's purge of LGBT people from the civil service, the military, and the RCMP, which lasted until the mid 1990s and went as far as the invention of an ineffectual homosexual detection device dubbed the "Fruit Machine."[11]

Despite this culture of fear and oppression, queer people developed ways of finding one another and communicating amongst themselves. Gay bars and other hangouts and establishments existed prior to the gay-liberation era, but their patrons relied on coded language, double entendre, and subtle cues in order to avoid discovery. A green carnation worn on the lapel was a common sartorial cue in the Victorian era,[12] while in mid-century United States, asking someone if they were a "friend of Dorothy" (in itself a double entendre, as the Dorothy in question was Judy Garland, a gay icon) would reveal if someone spoke the same language of desire as you did.[13] In the UK, a coded language called *polari* (derived from Italian parlare, meaning "to speak") was often used by homosexuals, theatre people, and parts of the criminal underground.[14] Even the word *gay*, which has had a number of meanings over time, from lighthearted and carefree to flashy, fine, or colourful,[15] was used throughout the first half of the twentieth century as a code word by those who understood the double meaning linking it to same-sex desire.[16]

From the 1950s to the early 1970s in North America, gay- and lesbian-rights groups began to appear on both sides of the border. The term *homosexual* was rejected by gay activists because it represented a clinical understanding of same-

sex attraction, suggesting that it was a mental disorder capable of being cured. Gay liberation was not a singular unified front, however. It was the result of many groups working towards a shared goal of fair and equal treatment for people who expressed same-sex desire. Lesbian groups, various ethnic groups, and Two-Spirit organizations formed to meet the unique needs of their respective demographics, often in reaction to the racism and misogyny found among some early gay organizations.[17] The use of the word *queer* by the LGBT community exploded as an act of political, social, and cultural reclamation after the AIDS crisis of the 1980s. By the early 1990s, LGBT activists had formed groups with names such as Queer Nation and ACT UP (AIDS Coalition to Unleash Power) as a response to the decimation caused by HIV/AIDS in the gay community and the anti-LGBT sentiments that arose in tandem. Tom Warner notes that this new generation of activists labelled themselves queer to indicate that "they advocated more fluid concepts of sexuality and identity that rejected both the necessity of labelling and the attempts to achieve a new, respectable identity that too frequently sought to impose stifling conformity."[18] The word that historically had been used as a slur became a calling card, an intentionally radical act of naming oneself and one's community.

Today *queer* is also used to supersede more rigid terms like gay, lesbian, and homosexual, which may not adequately encompass an individual's gender identity and expression as well as sexual orientation.[19] The term is not without its issues, however. Many 2SLGBTQ+ people do not identify as queer, either because it has been used against them in a hateful way or simply because they are not comfortable with the identifier. Yet queer people through the ages have invented, adapted, and reclaimed language in order to find each other, to express their affections, to collaborate and organize for social justice, and to shield themselves against oppression in times and places where their love was under attack.[20]

Same-sex desire has always existed. In the case of Len and Cub, their photos use subtle and not-so-subtle (but deniable) cues and clues as to what was present within them. What could be passed off as a friendly embrace was in fact a love language of its own, spoken only by Len and Cub, with the camera there to capture it all. The photos of Len and Cub in this book show a poignant love, whatever the language they would have used to describe it, that is plain to see. This rare and significant collection of images elucidates a quiet history of homosocial relationships in rural New Brunswick during the early decades of the twentieth century.

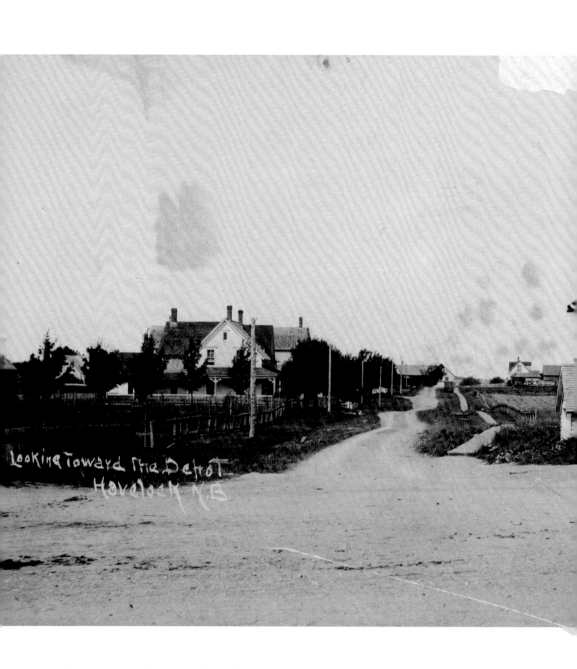

Postcard view of Havelock's Depot Street (now known as Cross Street), c. 1900.
The future site of Len's garage is behind the Mercantile, pictured right. (P46-442)

Beginnings in Butternut Ridge

The village of Havelock is located in Kings County about forty minutes west of Moncton in southern New Brunswick. Like many rural communities in the province, Havelock has seen many economic and demographic shifts in its history, all while suffering a continuous decline in population over the past century as younger generations have relocated elsewhere. Originally the village was known as Butternut Ridge, a nod to the abundance of butternut trees in the area, but when a line of the Intercolonial Railway passed through in 1886, the town was renamed, a common fate for many small villages and towns in the name of progress. The railway was built to service both the Petitcodiac and Butternut Ridge areas, and the town was renamed in honour of Sir Henry Havelock, a British general who had died during the Indian Rebellion of 1857.[1] The name change caused major consternation amongst the villagers, who continued to use Butternut Ridge, as did the post office. The Keith family persisted in using "Butternut Ridge" in their albums and listed it as their residence in official documents.

The rolling hills surrounding Havelock offer vistas of farmers' fields and the woodlands of Kings County. Early settlers, who had started to arrive by 1809, were attracted to the region because of the quality of the land.[2] Havelock

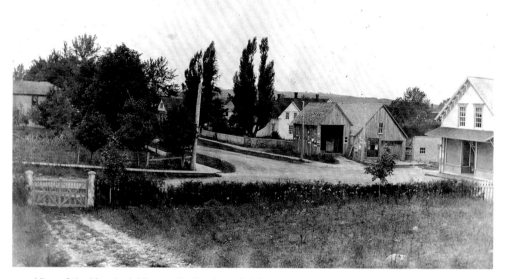

View of the Havelock Mercantile (furthest right) at the Depot and Main Street intersection, taken from the Anglican church, c. 1890-1900. (27-217)

has large deposits of limestone, which not only provides good fertile soil but later enabled the establishment of the Havelock Lime Works in the 1920s, an important industry for the village. The inland settlement relied on the Canaan River, which flows north of Havelock and was an important water source and fishing area for the settlers.

It was in this small New Brunswick village that Leonard Olive Keith was born on December 14, 1891.[3] The Keith family had been one of the earliest to settle in the area, along with Leonard's maternal ancestors, the Prices. Leonard, or "Len" as he was known affectionately by his family and friends, was the fourth son of eleven children born to Hilyard Atherton Keith and Agnes Florence Price.

Hilyard was an entrepreneur and merchant who owned a match factory and a grist mill with his older brother, Charles Israel Keith. The industrious Charles Israel also owned a store, butcher shop, and tailor shop, and was responsible for managing the town's public hall. Len was born at a time of economic misfortune for the family. Earlier that year, the match factory, which had been built only three years

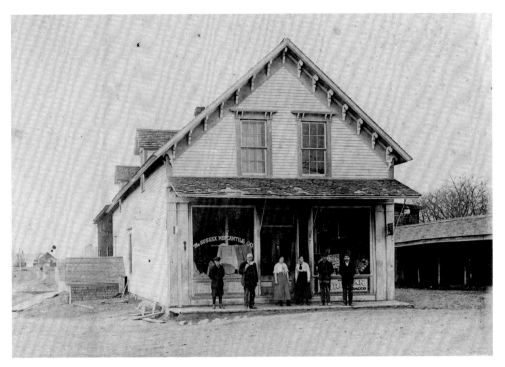

Charles Israel Keith (second from left) and his brother and business partner, Hilyard (far right), c. 1890-1900. (P27-842)

previously, burned to the ground, causing great financial hardship for the brothers.[4] They sold the business to the Corey Brothers and were also forced to surrender ownership of the Havelock Mercantile Co. to the S.H. White Co., merchants from Sussex. For nearly twenty years thereafter, Hilyard was employed as a manager until he was able to repurchase the store.[5] Hopefully, Len's birth at the end of that year of losses brought some joy to the family.

The Havelock of Len's early years had a population of around 150 people, with some 2,000 people scattered across the broader parish of nearly 300 square kilometres.[6] The Havelock Mineral Springs Company was a key employer in the 1890s and early 1900s. It produced sodas, which were becoming a popular beverage noted for their fun flavours and purported health benefits.[7] Havelock was located in the overwhelmingly rural Kings County, and although there were no major cities, the town of Sussex served as the commercial hub of the county. The county had a population of just over 21,600 in 1901, having slowly dwindled from 25,000 two decades previously as people sought better economic opportunities in the United

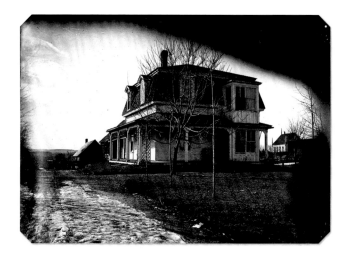

The Keith house remained in the family for almost 100 years and still stands on Cross Street (formerly Depot Street). (P27-196)

States and Western Canada.[8] The majority of the population of Kings County were protestant with the largest denomination being Baptist, closely followed by Anglicans. Catholics were a minority.[9] The county was largely made up of the descendants of settlers from the British Isles (English, Scottish, and Irish) along with a minority of settlers of French, German, or Dutch ancestry.[10] Agriculture was the driving force of the local economy, and with a heavy concentration of dairy farmers in Sussex, Havelock developed its own related business with the establishment of the Havelock Cheese Factory in the early 1900s.

Len's family, as merchants, were well respected and part of the Havelock elite. Agnes Keith's father, John C. Price, was the local magistrate and justice of the peace. Her brother, Dr. Leverett Price of Moncton, was a Boer War hero. Agnes was also close to her sister Glorana Harding Price Fownes, wife of William H. Fownes, a ship's captain. The early photos of the family show that Len must have had a childhood typical of a merchant family in a small Maritime village. After providing for their growing family and expanding their estate, the Keith family had enough disposable income to invest in luxuries such as automobiles and cameras. The family likely purchased their first camera around 1905, when some of the younger children appear to have been photographed around the farm.

Arthur Hicks was the first person to dabble with photography in Havelock. He began by taking ferrotypes or tintypes and then moved on to other forms of photography, developing the photos in his pantry.[11] Tintypes were some of the first "instant photos" and were inexpensive and easy to produce.[12] A photograph was taken and made positive when exposed on a thin piece of iron coated in lacquer to

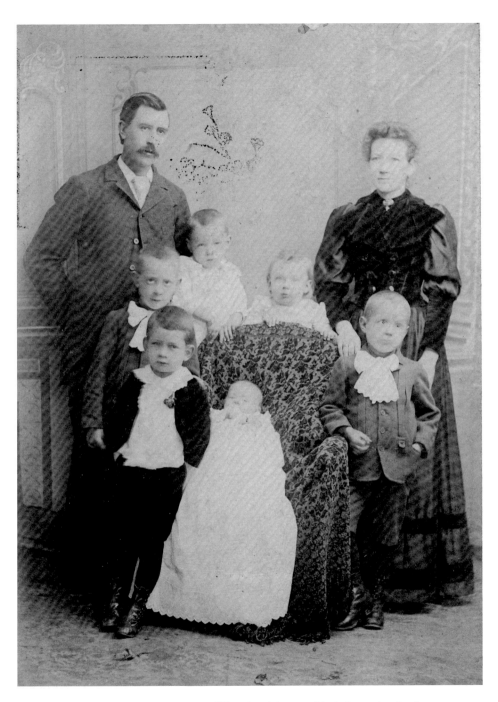

Keith family portrait, c. 1894. Hilyard and Agnes with their growing family:
William Fownes (b. 1887), Charles Hilyard (b. 1889), Robert Woodman (b. 1890),
Len (age 3, b. 1891, on Hilyard's immediate left), with the addition of two
new brothers Harold Lee (b. 1893) and Frank Austin (b. 1894). (P27-378)

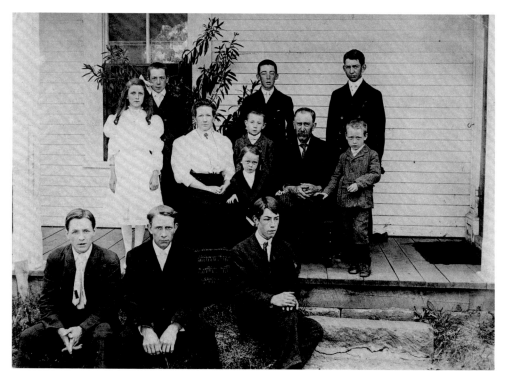

(above) Keith family portrait, c. 1908, with all ten children. The younger Keith children (born after the 1894 portrait) were Lucy Isabelle (b. 1897, standing back left next to John Cliff "Jack" (b. 1900), Walter Leon (b. 1901), on Hilyard's right, and Bliss Thorne (b. 1905), standing between Hilyard and Agnes. A second sister, Agnes Louise (pictured by her mother's knee) was born in 1907 but died later in 1908. (P27-849)

(left) Interior of the Keith family home. (P27-1033)

fix the image. Hilyard could easily afford Hicks's services and had portraits of his family taken on a couple of occasions in 1892 and 1894.

These cartes-de-visite (collodion prints pasted onto thick calling-card backing) were cheaply made and are unmarked, indicating that they were most likely done by Hicks, who did not have a professional studio. Still, the significance of the Keiths having the means to pay for these visual and social records of their family should not be overlooked. Hilyard and Agnes would have belonged to the first generation of Keiths to have the opportunity to take family portraits, creating these records that document their family. Some earlier portraits of Len's older brothers were taken in Moncton and as far away as Pridham's Studio in Sackville.

The many early family photos contained in the collection hint at Len's love of the outdoors from a young age and show him hunting and spending time with friends. Various photos show the Keith family on picnics with their cousins at a log cabin on Cranberry Lake in nearby Queens County. Around 1920, the family built or acquired a two-storey cabin near Hunters Home on the Canaan River, where the younger children and their friends enjoyed canoeing, hunting, and exploring. Len seemed to be closest to his younger brother Jack and his sister Lucy since his older brothers left home early. Fownes became a dentist in New Hampshire and eventually settled in Vermont. Charles became a farmer in Petitcodiac, but like nearly all of Len's brothers, he relocated to the States. The only exception was Bliss, who became a minister in the Anglican Church, living and working in various New Brunswick communities.

Keith family at Cranberry Lake, Queens County, c. 1905-1910. (P27-227)

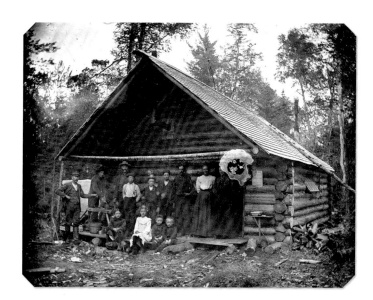

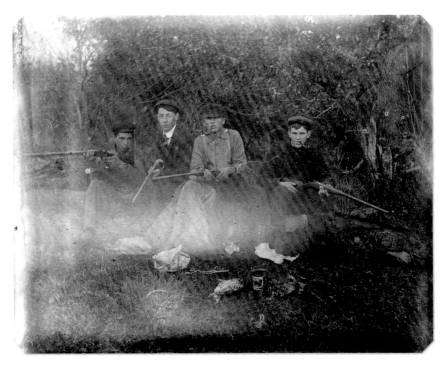

(above) Len, second from left, with friends on a hunting trip. (P27-346)

(below) The Keith family cabin at Hunters Home on the Canaan River, c. 1920. View of the laneway to the cabin, root cellar on the left. (P27-MS1H1-5)

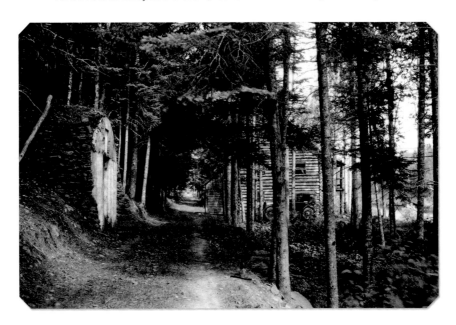

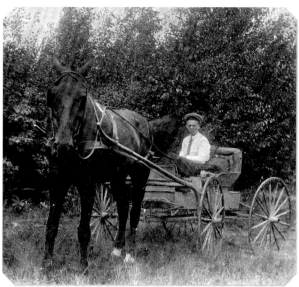

(left to right) Len as a young man, c. 1910-1915. (P27-221)
Cub in his teen years, photographed by Len. (P27-138)

Joseph Austin Coates was born on March 31, 1899, to Beverly Frederick Coates, a farmer, and Jennie Isabela Cummings. The second eldest son in a family of ten, he was given the nickname Cub due to his wolfish appearance, slightly upturned nose, and low, thick eyebrows. In most photos, he looks rather stern compared to Len, who is regularly pictured trying to contain a grin. However, other images show he also loved clowning around and surviving records testify that he was a very kind individual. He loved animals, particularly horses, and would later become very involved with harness racing in his adult years.

Len was eight years older than Cub and would have known him from the time he was born. Not only were the families neighbours, but the two boys' time at school overlapped, with Cub starting primary at age five when Len was twelve. The Coates family was well respected in the village but not as well off, and they likely did not enjoy the same status that Hilyard and Agnes had as pillars of the community. Hilyard was even a school board member at one point, and the family's comings and goings were highlighted in the local *Kings County Record* and even in Moncton newspapers. While Len's family was Anglican, Cub's was Baptist, but though each denomination attended its own church, there was no apparent ill feeling between the two main protestant denominations in the village.

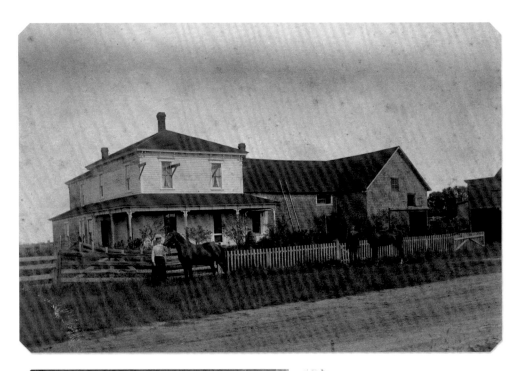

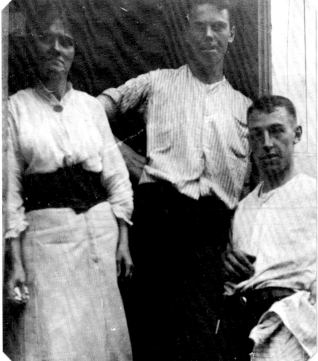

(above) The Coates farm and family home on Back Street close to the Keiths'. (P27-280)

(left) Cub and his mother Jennie Coates standing in the doorway of their farmhouse with Len at right, c. 1916-1920. (P27-1036)

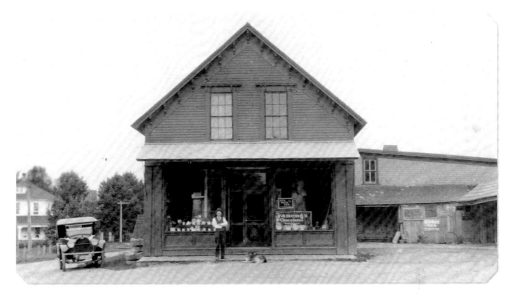

Charles Israel, Len's uncle, standing outside the Mercantile c. 1911-1915, Keith family car on the left. The signs in the window advertise Red Rose Tea, at that time produced and packaged in Saint John, and Ganong's Chocolates from St. Stephen. (P27-693)

The Keith family's status plays an important role in Len and Cub's story. The family's cachet no doubt provided a level of protection from critique or intense scrutiny during Len's formative years, and their ownership of a large property and access to luxuries such as a camera, would eventually help facilitate the documentation of Len and Cub's relationship. Despite any minor differences in status, religion, and age however, Len and Cub would go on to develop a special kinship.

Photography was not the only modern invention the Keith family embraced. Hilyard was the first person in the village to purchase an automobile, around 1911,[13] and this purchase was to be monumental. From that time on, cars became a huge part of Len's life. A car was an important addition to the family business too. Travelling to and from meetings, transporting goods, and making deliveries were all more efficient after the purchase of the car.

In addition to working as a clerk in the family business, Len was able to branch out and become a chauffeur for the Mercantile when he received his license in 1912 at the age of 20.[14] While New Brunswick farmers understood the need for good roads, cars were seen as "a rich man's plaything."[15] There had even been an attempt to restrict automobiles from rural areas because the horns frightened the animals.

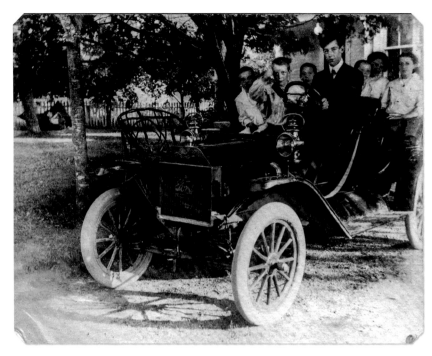

(above) Keith children piled into the family Ford, Len at the wheel. (P27-MS101-11)

(below) Cub Coates with the Keith family Ford on an excursion with Len, 1916. (P27-164)

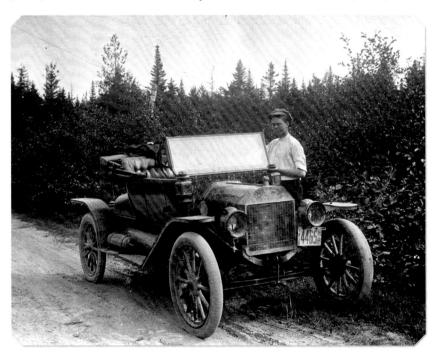

Len began attending Primary at the Havelock Superior School at the age of six in 1898. Records show that he had good attendance and progressed through grade school at the standard rate, Intermediate by age nine and Advanced by age twelve. He left school in 1910: one of only five students from his peer group to stay until the age of eighteen, the majority having left earlier to work on their family farms.[16] The Keith family valued academics, and their financial status made it possible for their children to access an education and attend boarding school to pursue higher studies. Fownes, for example, became a dentist in the United States, Jack and Bliss were sent to Rothesay Collegiate, and Lucy went to King's-Edgehill School for Girls and later King's College in Nova Scotia.

Len also had the opportunity, in 1914, to go to Tilton School in New Hampshire when he was 22 years old, but his scholastic career was not long-lasting. While he may have achieved an "A" in deportment, being the cheerful, kind fellow as he appears to be in his photos, his marks in other areas were less than stellar. While he showed a reasonable ability in geometry, he earned only a "C" in his study of the Shakespeare play *Merchant of Venice*. He failed junior algebra and didn't seem to have a strong aptitude for French, piano, or elocution either.[17] His mind and heart were clearly not focused on academics (as the photos on p. 70 show) but rather on socializing at school before returning to the rolling hills in Kings County. He left Tilton without graduating and returned to the Mercantile to help his father.

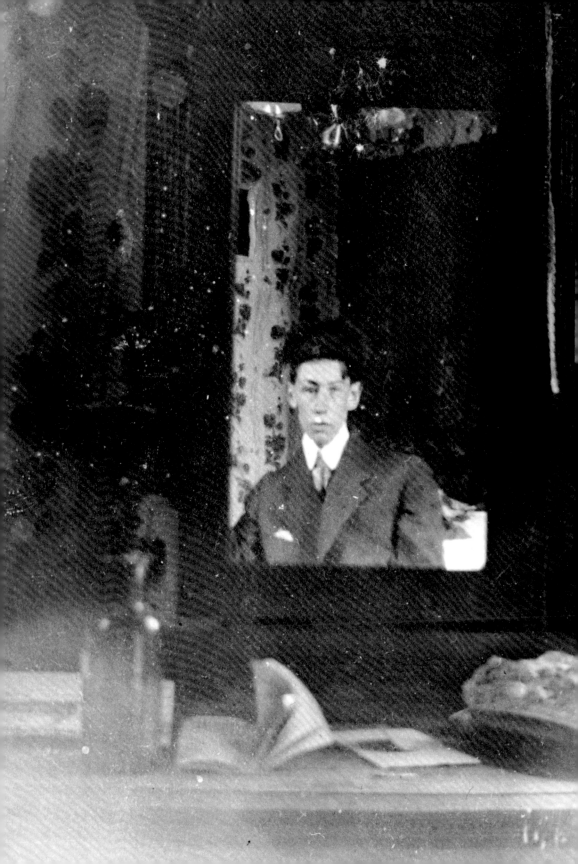

Len's Camera

By the early 1900s, when Len would have started to experiment with photography, cameras were far more accessible and easier to use than the bulky, complicated devices of the 1800s. The advent of the celluloid film roll for the Kodak camera, which arrived on the market in 1888, brought a great change for amateurs, especially when the Kodak Company established a headquarters in Toronto. The new technology was much more convenient and its impact was not unlike the move from film-based to digital photography in our own time.

Kodak's slogan, "you push the button, we do the rest,"[1] was essentially true. The amateur did not need to mess around developing a photo; a roll could simply be mailed away and the developed image returned by post. This led to a "snapshot revolution" and ushered in an explosion of amateur activity.[2] In this period of photographic frenzy, amateurs captured some of the most important events in the post-Confederation period, including the immigration boom, the Riel Resistance, and the rush to the Klondike in search of gold.[3]

Based on the print size of Len's photographs, measuring between 1 $^5/_8$ × 2 $^1/_2$ inches and 3 $^1/_4$ × 4 $^1/_4$ inches, it is clear that he owned a Folding Kodak. Proof that he used Kodak's

(left) Ad from the
*Kings County
Record* (August 26,
1910).

(below) A young Len.
(P27-MS1E1-51)

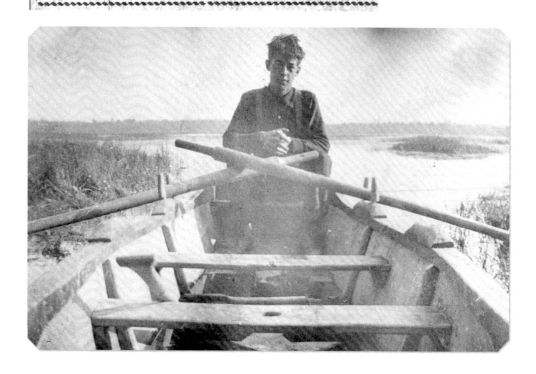

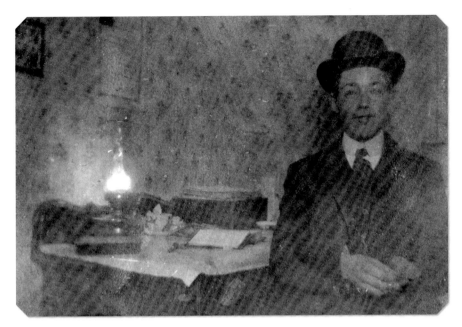

Portrait of Len, c. 1910-1915. (P27-MS1D1-22)

services is evident from the fact that he ordered several Kodak-branded albums in the 1910s and 1920s. Kodak supplies could be procured in the nearby town of Sussex at jeweler G. Suffren & Son. Len was not the only photographer in the family, as albums containing photos taken by Jack, Lucy, and Bliss also exist in the PANB collection. Len's interest in this new visual technology may have influenced his younger siblings to keep a visual record of their lives, but they did not capture the level of detail that Len did.

Before the First World War, the composition of photographs was steeped in what was known as pictorialism, which strove to "emulate traditional art media" such as paintings or sketches and became popular among amateurs.[4] Photographers carefully chose their subjects and developing processes, unlike "snapshooters," who simply wanted to capture themselves, friends, and family and knew little about the mechanics of the camera.[5] More serious amateurs like Len and, to a certain extent, Cub, "reverted to family scenes and favourite topics, often executing them with painstaking exactness."[6] There were very few shots taken by Len that are not of subjects important to him. Besides Cub, Len's pictures capture his family, family events, friends, the Keith family farmhouse, the family dogs, hunting and camping trips, the Mercantile, and later his garage.

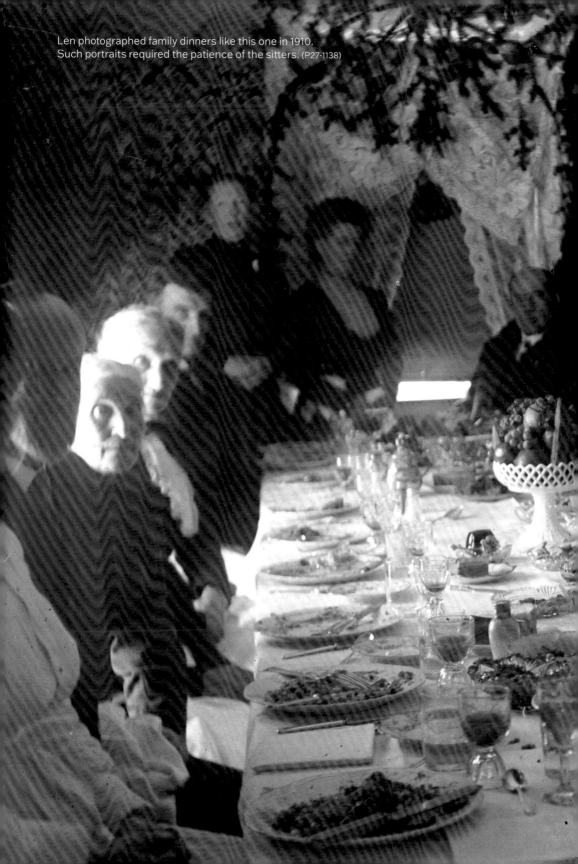

Len photographed family dinners like this one in 1910.
Such portraits required the patience of the sitters. (P27-1138)

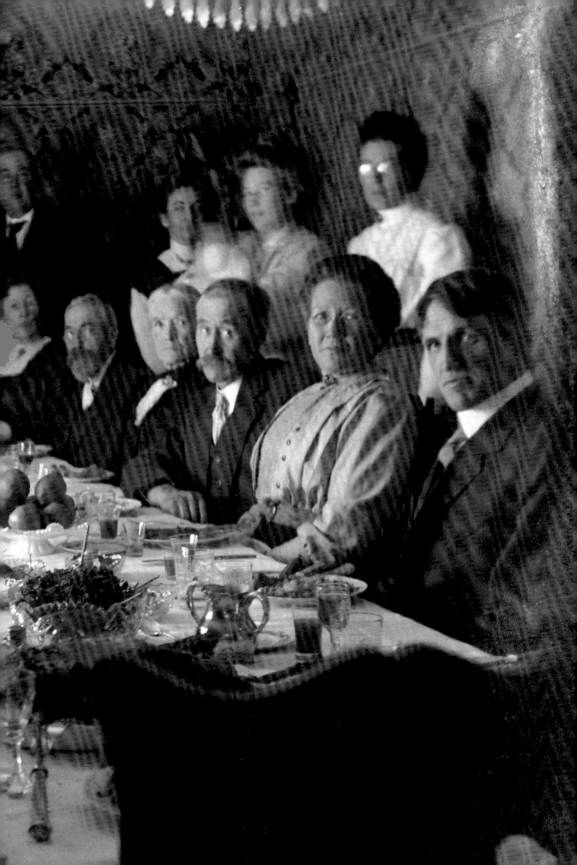

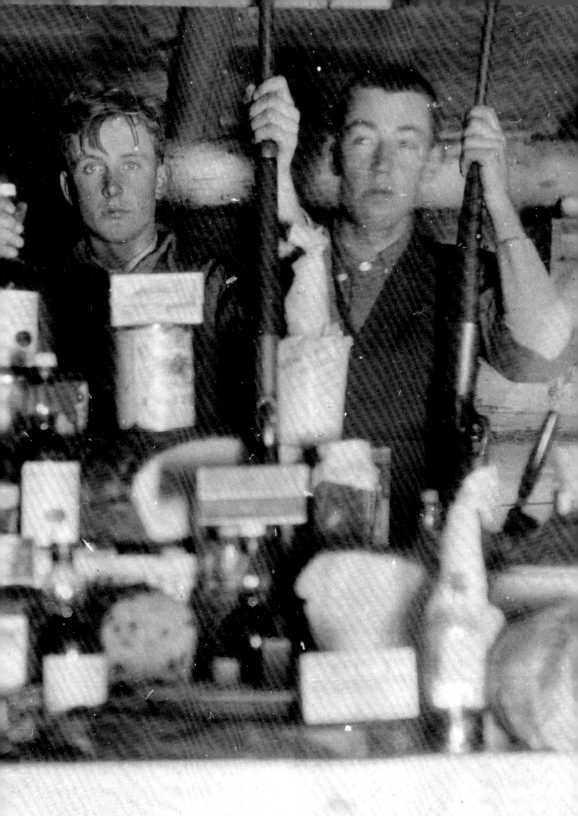

Len (far right), Cub (second from the left), and friends at camp. (P27-MS101-116)

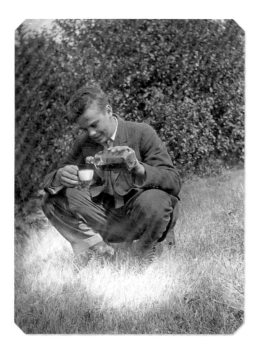

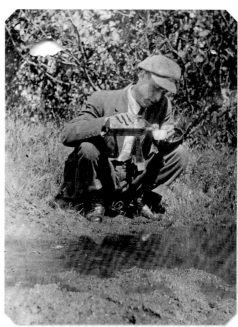

(above) Examples of Len's parallel portraits: Cub (left) and Len. (P27-126, P27-379)

(below) Cub and Len skating on a pond near Havelock. Len has his camera bag on over his overcoat, c. 1915-1925. (P27-MS1O1-158, P27-MS1O1-159)

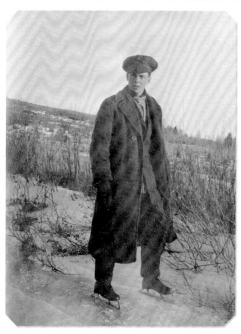

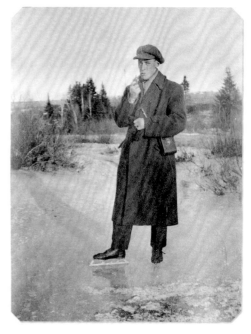

Amateur photographers were often members of local photography clubs, where trends developed and techniques were refined. Although there is no record of such a club in Havelock, the breadth and diversity of Len's photos blur the lines between a simple snapshooter and an artistically minded amateur.

From very early on, Len liked to experiment with his camera. The self-portrait on page 40 shows Len carefully photographing himself in a mirror. He is not looking at the camera but at himself, similar to a modern adolescent's penchant for taking "selfies." This photo shows that Len had a vision for the finished product in mind, as he makes eye contact with himself rather than the viewfinder on the camera out of sight in his lap. Similarly, the portrait with his friends with a carefully arranged display of camp goods illustrates Len's close attention to composition (pages 46-47).

Records of Len and Cub's time together are scattered across several photo albums belonging to Len and his siblings and reams of loose photographs that make up the bulk of the Corey collection. Among these are a number of photos, fifteen to twenty, that appear to have been taken just moments apart in which Len and Cub swap positions in a staged scene in order to create dual portraits. These parallel photos usually show Len and Cub partaking in one of their many shared interests, be it hunting, drinking alcohol, camping, or just driving around in Len's Ford.

There are many photos of Len and Cub together, but the swapped portraits, in particular, show another side of Len's artistic bent as he experiments with subjects and techniques to create parallel portraits. That is not to say that anyone, even Len, would have considered them notable works of art, but they are interesting pieces that speak to Len's experimentation with his Kodak.

The seemingly solemn portraits that are common in early photographs have led to the misconception that these images depict past generations of stoics who did not joke around. The reality is that most early cameras required long exposures to make sharp images; the apparent solemnity of the subjects is only a response to the technology, not an indication of their personalities. It was only the advent of less expensive cameras with faster lenses that helped bring about the idea of photos as slice-of-life snapshots rather than terminally posed portraits. However, even when working with long exposures it is clear that Len was a photographer with a sense of humour. As amateur photography became popular, home portraits and candid photographs that captured the lighter side of life rapidly increased in number.

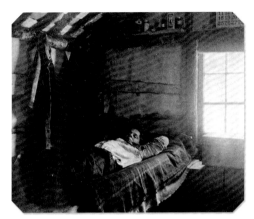

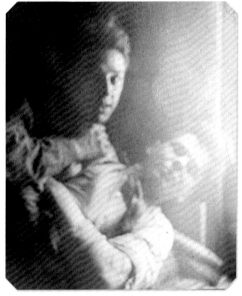

(clockwise from above)
Cub alone in bed in the cabin. (P27-MS1O1-128)

Len has set the self-timer and jumped into bed with Cub, but not quickly enough to avoid some blurriness and over-exposure. (P27-MS1O1-130)

Later experiments with a self-timer. (P27-MS1F1-112-1, P27-MS1F1-112-2)

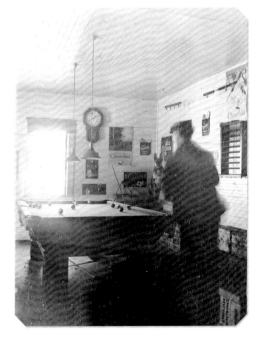

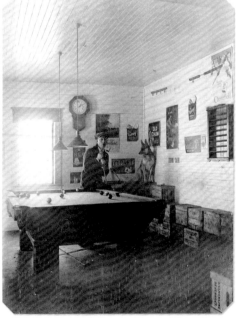

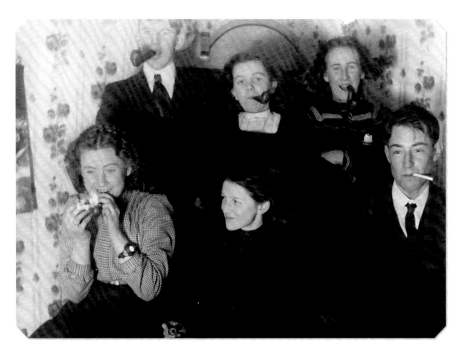

Len (bottom row, right) and sister Lucy (bottom row, centre) enjoying a "smoke"
with friends in the Keith parlour. (P27-MS101-20)

Kodak self-timers became available in 1917–1918. Several intimate snapshots of Len and Cub around this time seem to have been taken using a self-timer—the images are blurred, suggesting Len had rushed back to pose after setting the self-timer. One example of a self-timed photo was taken in the mid-1920s and shows Len playing pool in the garage with the family dog. Because he was unable to get into frame fast enough, a blurry Len is caught running towards the end of the pool hall. In the next shot, he makes it just in time to perch atop the pool table. Before the advent of self-timers, photos of Len and Cub together were most likely taken by siblings or friends.

Len's camera was crucial in capturing a visual record of his life as a young adult in rural New Brunswick at the turn of the twentieth century. These photos document his environment and the things he enjoyed, but also his relationships with his family members and with Cub. The number of photos taken by Len, his experimentations, and his formal aptitude testify that he was both intrigued by the art form and took painstaking efforts to capture carefully arranged portraits of the people, places, and things he loved.

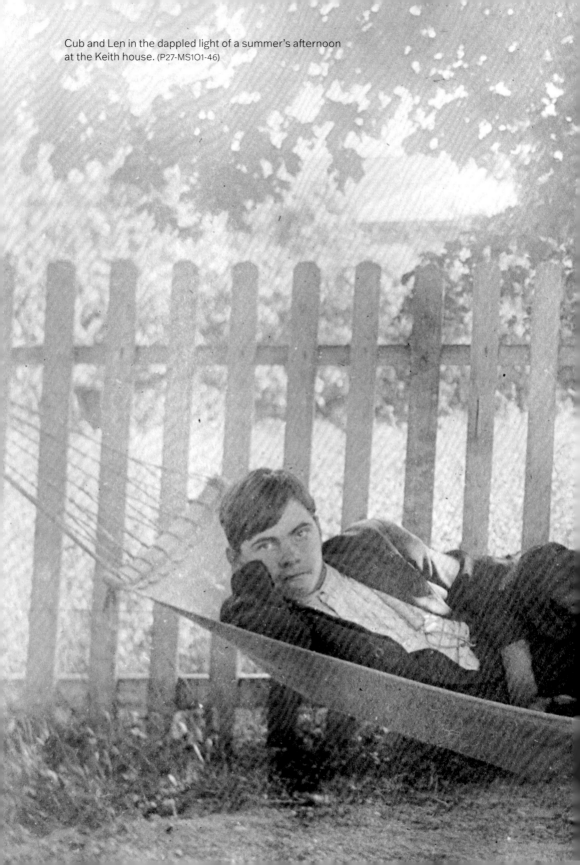

Cub and Len in the dappled light of a summer's afternoon at the Keith house. (P27-MS101-46)

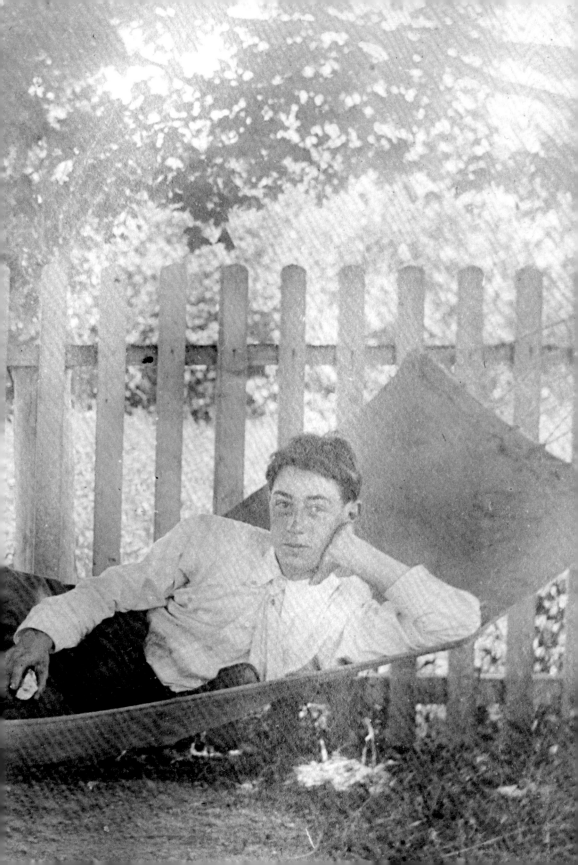

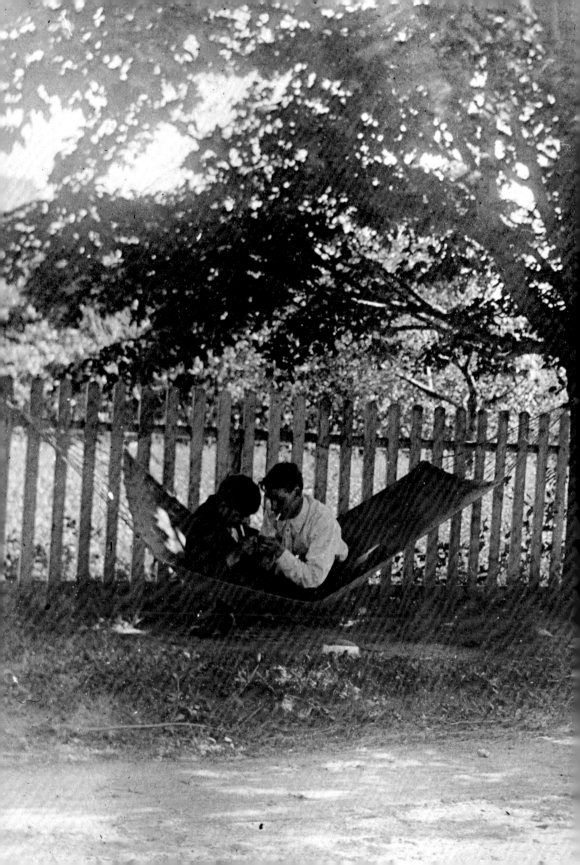

"The Love That Dare Not Speak Its Name"

To tell Len and Cub's story properly, it is important to give proper credits and caveats to its main source: a collection of black and white photographs and their donor, John Corey. The cliché that a picture is worth a thousand words may be quaint, but it's not useful when you want to ensure that those words are appropriate, factual, evident, and true. Where possible, the photographs must be combined with external research to properly contextualize them.

These photos and second-hand stories are our only records of the relationship, as all the other members of their generation have died. Len would have known Cub from the day he was born, but over time this friendship became deeper than boyhood camaraderie. The exact details of why they gravitated towards each other have been lost to time, but from the photos it is possible to glean information about their relationship by looking for clues in the settings, poses and demeanour, dates, subjects, and garb. This information was then corroborated by travel documents and news clippings, while simultaneously being interpreted through a queer lens. Through that lens, the deep connection and love between Len and Cub is evident in the hundreds of photos documenting their relationship taken by both men.

Cub and Len. (P27-MS1O1-49, detail)

Even with the remaining records of Len and Cub's lives, loose ends and ambiguities abound. As time passes, anecdotes fade, records crumble, and living contacts pass away, a certain amount of reading between the lines of history is necessary. Still, it is remarkable that these photos exist at all. To end up housed at the Provincial Archives, they first had to have been taken by Len, sent for developing, and preserved by Len throughout his life, then held on to by his sister Lucy, acquired by John Corey at the Keith family estate sale, and finally donated to the archives. During this time, photos have no doubt been lost or destroyed, as Len, Lucy, or even John may have been concerned with the legal or social repercussions of owning records that depicted a same-sex relationship too transparently. As far as we know, there are no love letters between Len and Cub and no photos of them being more intimate than those in this book. As we explore what Len and Cub's relationship might have been, it is important to remember that the remaining records are a product of their time, when a homophobic undercurrent prevented same-sex couples from living and loving openly.

Queer records from the early 1900s are rare, and as such, scholarship on queer rural Canadian experiences from this period is scanty. It is clear Len was smitten with Cub, and vice versa. John Corey, who donated Len's collection to the Provincial Archives of New Brunswick, grew up in Havelock hearing about Len and Cub. He understood the significance of these records, making a point of remarking to the archivist during the donation process that the pair were "boyfriends" and that Len was driven out of town for being a homosexual. Many of the photos support this narrative and show the means by which their relationship was allowed to blossom in that time and place and the lengths they would have gone to conceal the true nature of their affection.

During Len and Cub's formative years, the terms *homosexual* and *heterosexual* would not have been part of the vernacular of the villagers of Havelock. Such definitions of sexual orientation were largely reserved for use by early sexologists working to develop new models of decoding human sexuality. Still, an absence of language or classifications to define oneself did not mean that same-sex love was accepted. "Unnatural" sex (i.e., non-procreative sex) was stigmatized by religion, queer sex was prohibited by law, and to live and love openly was virtually impossible for same-sex couples. So how might the boys have understood and interpreted their same-sex attraction? Would they have been bothered at all by any notions of stigma around queer sex and love?

North American society underwent a massive shift in its understanding of human sexuality between 1900 and 1950. Queer historian John Howard describes this cultural and social reckoning as "the great paradigm shift" through which various cultural groupings across North America began to interpret sex-object attraction as an identity, "not as [a] behaviour, but [as] a state of being,"[1] effectively creating a binary classification of sexual orientation: heterosexual or homosexual. The impact of this binary was ubiquitous and nearly inescapable for much of the twentieth century, as it permeated so many aspects of our lives.

This highly heterocentric and gendered binary had an outsize influence even in gay circles. In *Gay New York: Gender, Urban Culture, and the Making of the Gay Male World 1890-1940* (1995), George Chauncey discusses how, before the Second World War, working-class men seeking sex with men in New York City were generally divided into two categories: "normal" men and "fairies."[2] In a world where gender status and presentation superseded any notion of orientation, fairies adopted a range of "non-masculine" signifiers such as red bow-ties, flashy clothing, powdered cheeks, and perfume. The fairy, a predominantly working-class identity, was a relatively small but notorious category of queer men who subverted gender roles in order to find sex, money, or community. A few even went as far as to wear women's clothing (which was illegal at the time) and adopt feminine names and pronouns to signal to "normal" men (often sailors, soldiers, bachelors, or closeted married men) that they were more like women than they were like men and desired to play a passive, receptive, "feminine" role during sex.[3] Men would conduct these encounters in a variety of places integral to an urban setting—hotels, tearooms, docks, alleyways—places where men of different classes and backgrounds could frequent, socialize, or conduct their affairs in relative privacy.

Chauncey argues that because the fairies presented a feminized gender status, they posed little threat to their suitors' masculine self-image. The fairies were understood to be "pseudo-women" or "inverts" who were in some way "psychically female" but anatomically male.[4] It was seen as inherent to their state for them to be attracted to men, all while their suitor's masculinity was never questioned. The suitors were simply men acting out their masculine gender status.[5] This active/passive binary harkens back to the dynamics of relationships between men in Greek antiquity or even later on in the twentieth century in some Black communities where men "on the down low" could have sex with other men without ascribing sexual identity to their acts.[6]

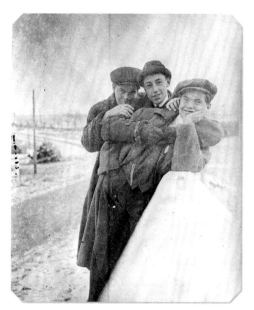

(left to right) Cub nestled on Len's shoulder, with their friend Ryder. (P27-MS1O1-157)
Cub, their friend Peewee, and Len. (P27-MS1N1-57)

Various class and ethnic groups disapproved of the fairies, and queer sex and transvestism were still criminalized in law and stigmatized by the general population.[7] Yet this understanding of active and passive sex positions as they relate to masculinity and femininity wasn't absolute. Many middle-class men seeking sex with men rejected the idea that they were somehow psychically female and desired to carve out their own identity as men who just happened to desire other men. They were often repelled by the "fairy's flamboyant style and his loss of manly status."[8] With much at stake in terms of employment and social status, some middle-class gay men were reluctant to shed the comforts and privileges of manhood, choosing to pose as "normal" men when seeking out sex with men, while others just "did it" as discreetly as possible for fear of being associated with the fairy subculture.[9]

Chauncey's exploration of the relationships among fairies, middle-class gay men, and their suitors (so called "normal" men) shows that definitions around sexuality at the turn of the twentieth century were in a state of significant flux. Old and new ideas about male sexuality and gender were clashing in New York's bars, bathhouses, and cruising areas, and men seeking sex with men began to develop a

sense of identity (and in the case of the fairies, community) linked to their same-sex attraction.

While the queer subculture of New York's nightlife would have no impact on the lives of two young rural New Brunswick men, a lack of queer visibility or alternative representations of gender and sexuality in Havelock allowed Len and Cub to fly under the radar, or pass as straight. The fact that Len and Cub were young men who worked and dressed in conformity with their masculine gender status would have been enough to avoid public suspicion from their fellow villagers for some time. Yet this view of same-sex attraction may have contributed to Len being driven out of town, though not Cub. Len was older than Cub, a seemingly confirmed bachelor who never dated or spent much time with women; he may have been perceived as truly queer in the derogatory sense, an oddball, someone suspect, who just didn't fit in and was therefore worthy of being ostracized. This gender-centric understanding of sex and sex-object attraction is important to keep in mind as we explore Len and Cub's relationship between 1916 and 1930, as it exposes some of the social and sexual undercurrents operating during their youth.

The vast majority of scholarship around same-sex desire during this era draws on urban rather than rural experiences like Len and Cub's. However, as Emily Skidmore writes in *True Sex: The Lives of Trans Men at the Turn of the 20th Century*, queer historians have been working since the early 2000s to counter this urban-centric view of queer experience by exploring traces of same-sex relationships in rural areas.[10] It should be noted that queer people who act on their desires, no matter where they live, test invisible yet very real and pronounced social boundaries of sex and gender in order to pursue their affections.

By the early 1930s, North American society had become increasingly concerned with policing the boundaries of gender and sexuality as a direct response to the perceived decadence and debauchery of the Roaring Twenties. By mid-century this policing had led to an extremely rigid divide between heterosexuals and homosexuals, firmly entrenching heterosexual men as the pious, patriotic, masculine standard and homosexual men as their immoral, feminine, perverse opposite.[11] With this in mind, it makes sense that Len would be outed in the 1930s as the stigma around queer people was on an upswing, and society's moral policing of gender roles more actively sought to suppress deviation from the norm. Ironically, the fact that men and women operated in distinctly segregated social spheres inadvertently provided space for same-sex romantic friendships to develop without

intense scrutiny as to why two men or women might be spending so much time together.[12]

Queer historians tackling this early period, such as George Chauncey, John D'Emilio, and Colin Spencer, provide ample evidence that the half-century before the Second World War is filled with examples of men having sex with men without reflecting on how their sex lives might shape their "identity" or "state of being." Be it German military recruits in 1910 who weren't concerned with "talk of homosexuality, they just did it,"[13] discreet middle-class gay New Yorkers posing as "normal" men, or queer boys from the American South who "did not sit around and have intellectual conversations about being gay... [y]ou just did it, and didn't do too much speculating."[14]

Len and Cub lived in a complex era, but in some ways their love may have been less complicated than our preliminary stage-setting suggests. It is possible that Len and Cub's relationship developed without much worry over the personal implications of their same-sex desire for their sense of identity. Where you did it mattered, and who knew about it, but the boys no doubt took precautions to hide the true nature of their affections. Yet, same-sex desire was in no way endorsed, and so their romantic entanglement could never have been acknowledged publicly.

Cub and Len preparing for an outdoor adventure. (P27-MS1O1-122)

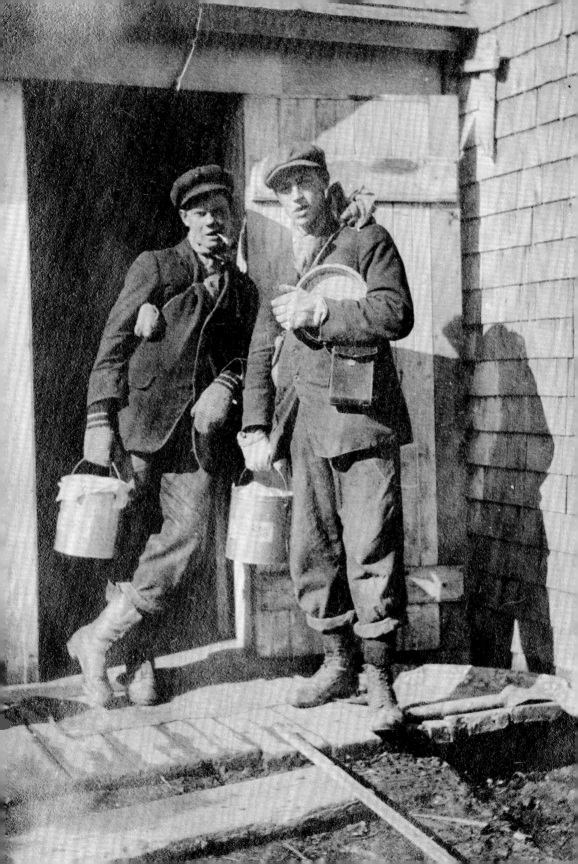

Cub and Len in an intimate embrace,
lying together in a wooded area.
This is one of many original glass plates
from Len's collection that have been
damaged over time. (P27-345)

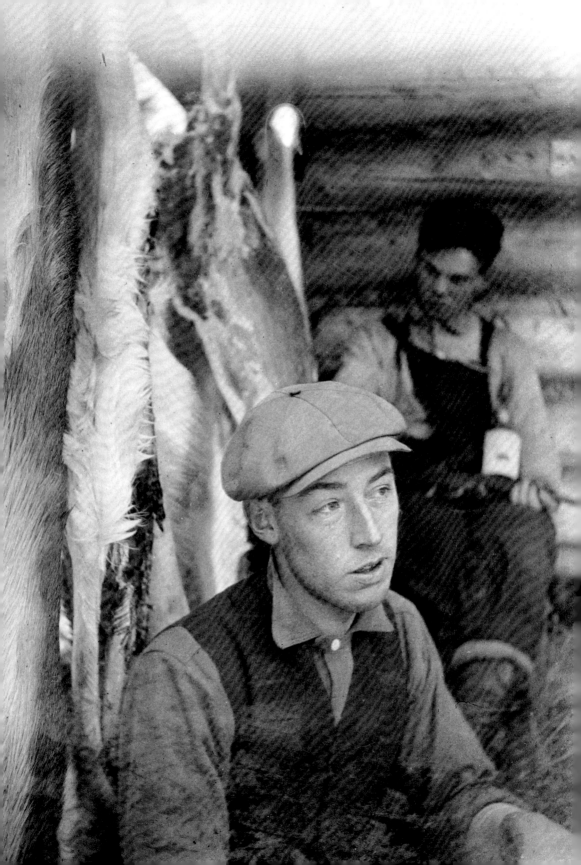

The Pursuit of Affection

The story of Len and Cub isn't just about who they were but also about the actions and choices they made. The most important—and most telling—choice was to document their affection towards one another through Len's photos. One of the easiest ways to do so was simply to get away and be alone together, hiding openly under the guise of male friendship, the manly act of hunting, and the freedom of the road.

That freedom was afforded to Len and Cub largely thanks to the Keith family's status in Havelock, which provided them with a number of locations and opportunities to spend time alone together. Given the size of the Keith estate, Len may have had access to a private bedroom of his own, and there were several outbuildings on the property that could provide relative privacy at times. Ever the outdoorsman, Len had a tent that he could set up in the backyard or pack into the Ford for road trips and camping excursions. There are also photos of Len and Cub alone together at a tarpaper shack as well as at the Keith family's hunting cabin at Cranberry Lake.

Through work and family Len also had access to the Havelock Public Hall, the Mercantile (which included stables and a storehouse), and eventually his own private business—

Len and Cub at the Cranberry Lake cabin, c. 1915-1916. (P27-148)

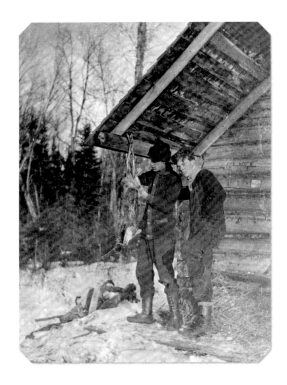

Len and Cub at the Cranberry Lake
cabin, c. 1915-1916. (P27- MS101-110)

the garage-turned-pool hall. Len's photo albums show that the pair had access to plenty of locations where they could find an excuse to be alone together, and photos show that they regularly took advantage of this. With plenty of locations at their disposal, and the mobility to get there, it is no wonder that there are more photos in Len's collection of him and Cub together from around 1915 to the early 1920s than of any other people. There are plenty of photos of the pair together with friends in merely affectionate and chummy poses, but the images of Len and Cub alone together display a more intimate relationship than a simple boyhood friendship.

The boys were unusually mobile for young men of their time. Cub's long-standing love of horses meant that he was usually in charge of driving horses and carts, and many of the photos show him leading the reins. Meanwhile, Hilyard's purchase of the family Ford in 1911 would play a pivotal role in Len's life. Len, having taken a shine to automobiles, developed a passion for mechanics and he was soon entrusted with the Ford. By 1916, it would prove to be a massive boon to Len and Cub's relationship. Photos show them in the countryside of Kings County on picnics and camping trips posing with the car. It allowed them to travel to the hunting lodge with friends but also to spend time alone with each other. To young men like Len

and Cub, the automobile would have been exciting. With its intriguing mechanics and top speeds of 50 to 60 kilometres per hour, the family car provided the pair with a level of freedom and mobility unknown to most rural New Brunswickers at the time.

Access to the family Ford bolstered Len's interest in mechanics. The Ford was also a tool that gave Len and Cub an unusual level of autonomy and privacy. In Tim Retzloff's study of gay life in post-First World War Flint, Michigan, "Cars and Bars: Assembling Gay Men in Postwar Flint, Michigan," he notes that the significance of the automobile for same-sex desire, particularly in rural communities, cannot be overstated.[1] For gay men living away from city centres, automobiles allowed visits to bars and cruising areas in town, but in Len's case, no such places are known to have existed within driving distance of Havelock at the time. Cars and roads not only acted as pathways to queer desire, they could also be used as locations for sex. Increased mobility allowed men seeking sex with men to drive to remote locations or park on the side of back roads to escape prying eyes.

The development of New Brunswick's roads and Len's access to an automobile would have provided Len and Cub with ample opportunities to drive out to one of the Keith family's properties to go hunting, swimming, or just "out for a drive,"

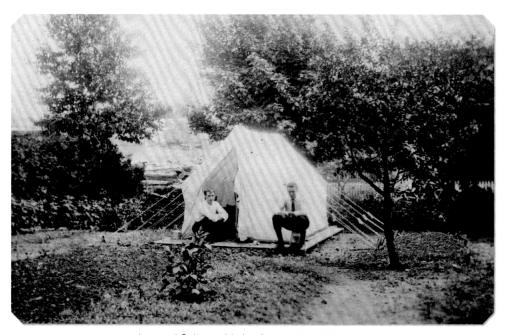

Len and Cub outside Len's tent. (P27-MS1B1-056)

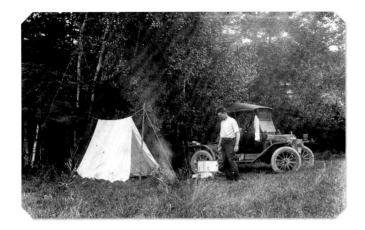

(top to bottom)
Cub stokes a fire outside
Len's tent. (P27-151)

Len poses on a road
outside of town.
(P27-MS1F1-146)

Cub poses in the same
location. (P27-MS1F1-147)

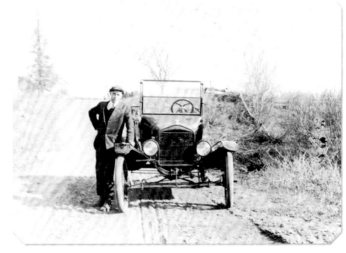

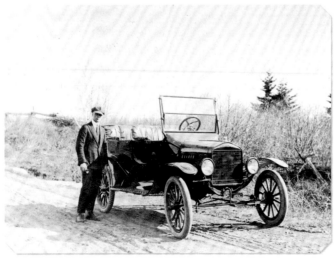

often to some remote location. Such outings were central to their time together. There are plenty of photos of Len and Cub posing with the car by the side of the road or next to Len's tent in the wild. Without the Ford, Len and Cub's mobility would have been limited to the few properties belonging to their families within the town limits of Havelock. Even in later years, the car remained central to Len's love life—pictures from 1929 show him journeying to Toronto with an unknown companion. Whether it was used for work at the Mercantile, running errands for the family, or love and leisure for himself and Cub, Len seems to have gotten more use out of the Ford than any other member of the family. It was a way out of Havelock, out of its familial and social constraints, and onto a path of freedom to pursue affection.

By the summer of 1914, Len had returned from his lacklustre stint at Tilton School in New Hampshire, while Cub would have been around 15 years old. Despite knowing each other well before 1914, it was after Len's return from Tilton that Len and Cub found themselves frequently spending time together. Cub's prevalence in the photos from this period may not be remarkable in itself, but the poses and demeanour are undeniably intimate. Photos from this period show them at their most affectionate: holding hands, wrapping their arms around each other, or lying together either in a cabin bed or outdoors in the meadows surrounding Havelock.

Len may have begun to explore his same-sex desires while attending Tilton. He appears to have had an active social life while living away from home, and his grades show that he was far from studious. Traditionally, homosocial spaces such as boarding schools have always been environments where same-sex desires have been explored. Historian John Howard notes that, in such homosocial spaces, queer sex was not always indicative of homosexuality. In fact, in many boarding schools sex between young men was so common that male students would have girlfriends with whom they attended social events during the evenings and male friends they would have sex with once they returned to their dorms at night.[2] While not everyone engaging in queer sex at boarding schools was necessarily considered gay (either by themselves or their peers), these institutions inadvertently provided a space for queer men to meet each other and for men seeking sex with men (or sex at all for that matter) to find willing partners.

A theory prevalent among sexologists at the time was that homosexual attraction occurred due to "accidental absences."[3] Boarding schools are a prime example of "accidental" absence of the opposite sex (or what was deemed the "natural object"), and therefore likely to create same-sex desire among students. Len's

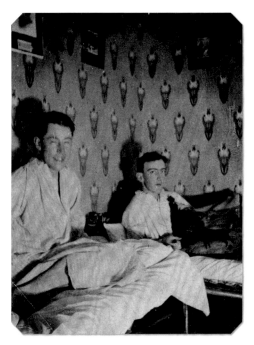

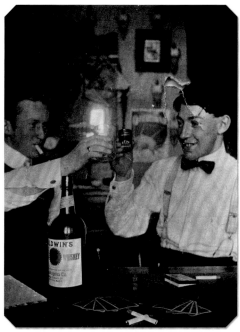

(clockwise from above)
Len and his roommate, Ira Lord, in his dorm room at Tilton. Len was not completely enamoured with Lord, writing on the back of the picture that he sent home to his family, "My room mate is a fellow about like Jack. You can talk to him and have him looking at you and when you get done he will ask you what you said." (P27-375)

Len and a Tilton chum share a toast in Len's dorm room. (P27-348)

Len with fellow students at Tilton. Len is near the top of the stairs looking towards the camera. (P27-152)

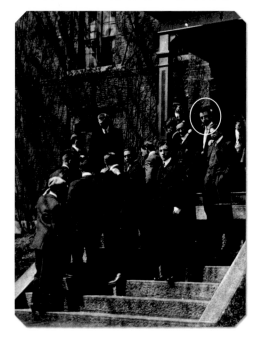

experience at Tilton would not of course have created his attraction to other boys or led him to become a homosexual, as sexual attractions are innate, but it may have opened his eyes to the fact that sex with other boys was possible. Living away from home in a sex-segregated college dormitory would have provided Len with ample opportunities to meet other young men who, like him, were interested in men. As is to be expected, the majority of Len's photos from Tilton show him socializing exclusively with other men. Tilton's distance from Havelock, in addition to its homosocial spaces, would have given Len security to focus on homosocial relationships and broaden his understanding of his sexuality. But once school was over and Len returned to Havelock, he had to find another socially acceptable form of plausible deniability for spending time with other men.

Although Len was outed in the 1930s, it's unlikely that suspicions would have been aroused by the amount of time Len and Cub spent togeth-er during their youth. While rural communities, even today, are not known for their willingness to accept deviation from social norms, they also tend to stifle public discussion of private matters such as the sex lives of their citizens. Havelock's citizens may have adopted an all-in-this-together attitude that further hushed up any public judge-ment of unorthodox practices.[4]

What might have been said behind closed doors is another matter entirely. If any suspicions about the young men's time together existed, the Keith family's elite status in the village may have

c. 1916. (P27-MS101-93)

helped squelch any gossip about Len and Cub's activities.[5] As youths, their comings and goings probably weren't noticed by average Havelock villagers busily working on their farms or small businesses or attending church. Whenever it was that Len and Cub's friendship developed beyond boyhood camaraderie, it seems unlikely that anyone would have noticed.

What began as a simple boyhood friendship evolved into one of the most import-ant relationships of their formative years. Len and Cub appear together in photos more than any other pair in the John Corey collection, and Len took more photos of

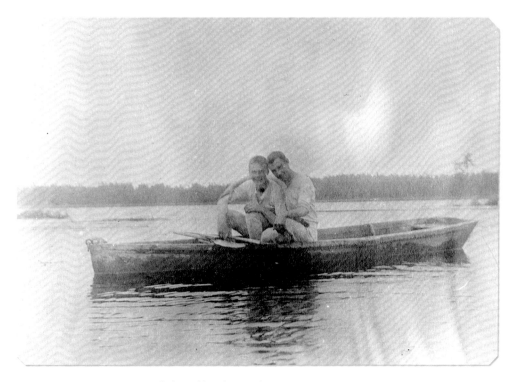

Cub and Len in a rowboat. (P27-MS101-136)

himself with Cub than he did with any other friend or member of his family. Photos from their youth portray a love and intimacy that may have gone unremarked at the time, but we can recognize it as historically exceptional and significant today.

Of particular note are the photos from this period (e.g. pages 8, 73, and 77) that feature Len and Cub wearing rings, usually on their ring fingers and occasionally on their little fingers. While it was not uncommon at the time for men to wear rings, it should be noted that they are often seen wearing them together, and after his time with Cub, Len is not pictured with a ring again. While this could be incidental, it is noteworthy that the boys sometimes wore rings on their ring fingers while they trekked into the wilderness in their overalls, and they are also pictured wearing these rings during their military training in Saint-Jean-sur-Richelieu, Quebec. These rings may have been a love token or a symbol of their bond.

(opposite) Len and Cub at the door of a tarpaper shack,
both wearing rings on their left ring fingers. (P27-MS101-124)

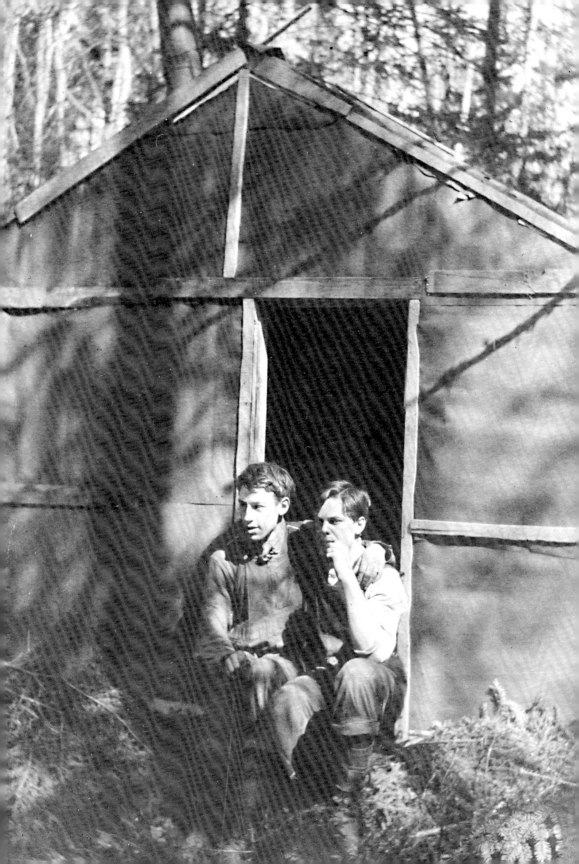

. . .

A year-end police report published in the *Daily Telegraph and the Sun* in 1914 indicated that three men had been arrested by the Saint John City Police for committing an "indecent assault on another man." County court records are not complete for these years, so finding records of police reports, judgements, or even dismissals has unfortunately proven difficult. Like the enabling environment of New York at this time described by queer historian George Chauncey, the urban environment of Saint John would have offered many more opportunities than Havelock for men to seek out other men and act on their same-sex desires discreetly. As a port city, Saint John would have had a transient population of mariners and travellers, and like many cities in Canada and worldwide, the dockyards and back alleys would have become cruising areas for visitors and local gay men.[6] Havelock may as well have been worlds apart. It certainly had no docks or seedy alleys, but Len and Cub could still have easily found places to be alone together in this rural environment. The Keith family's Cranberry Lake lodge, for example, was only thirty-eight kilometres away and could be reached quickly by car, but it would have been a full day's trek by most other means. The Keiths would have been one of only a handful of families to own a car at the time, adding further privacy and safety to Len and Cub's rural outings. Aside from the Keith family properties, there are also many photos of Len and Cub exploring the wilderness and camping in Len's tent.

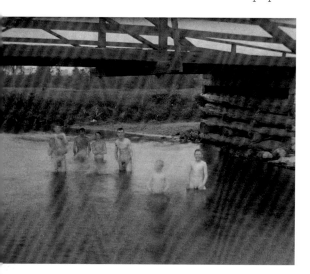

Skinny-dipping at Seeley's Bridge, Canaan Road, c. 1910-1915. (P27-248)

To say that Len and Cub's youthful love could not last forever is to give short shrift to their situation. The society that turned a blind eye to their affections was about to undergo a massive schism that would reshape social mores, focusing on what was to be called a "traditional" nuclear family.

(opposite) A particularly intimate and affectionate photo of Len and Cub. (P27-MS1-O-127)

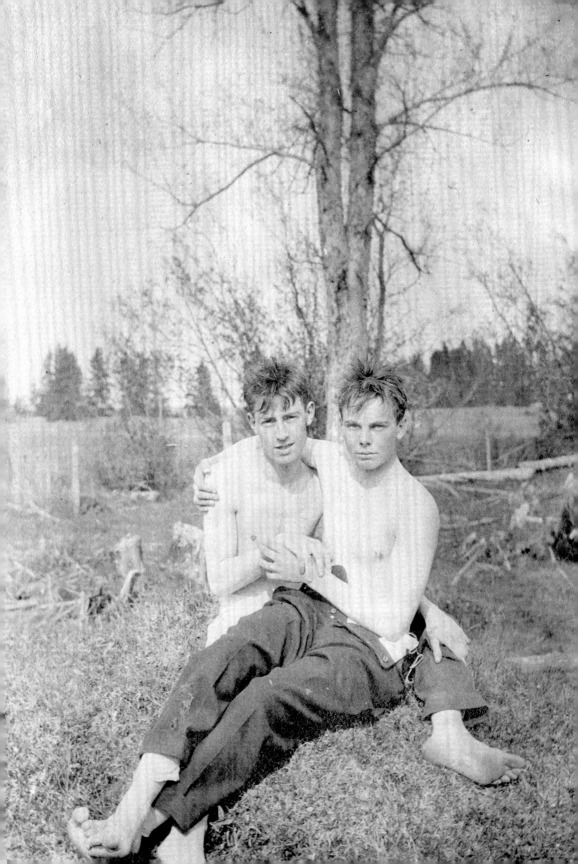

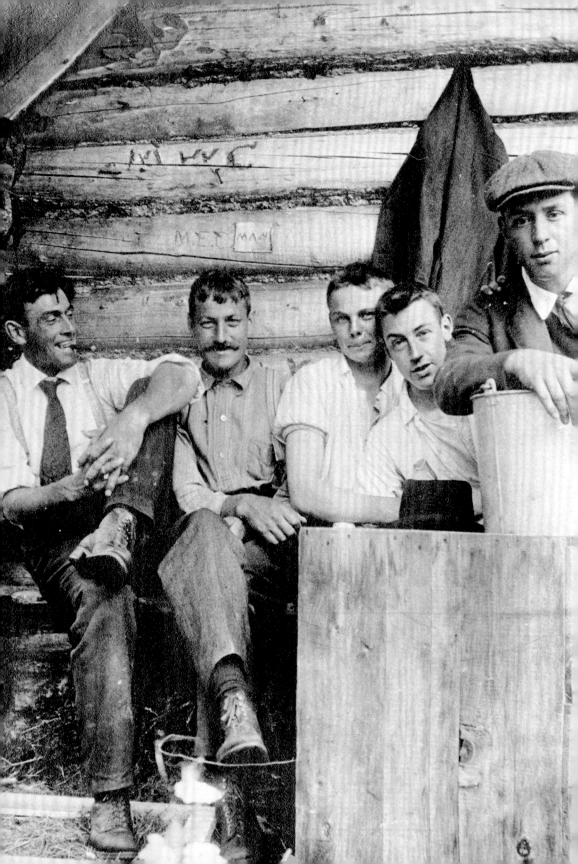

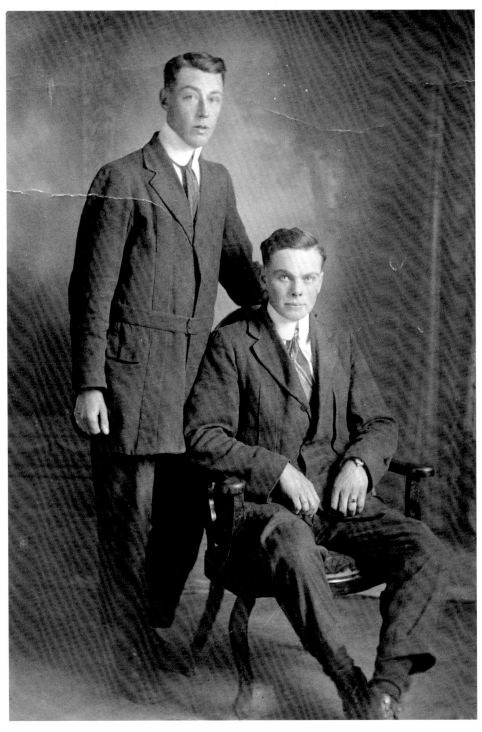

(above) A commercial studio portrait of Len and Cub. (P27-349)

(opposite) With friends at the Cranberry Lake cabin. (P27-MS1O1-139)

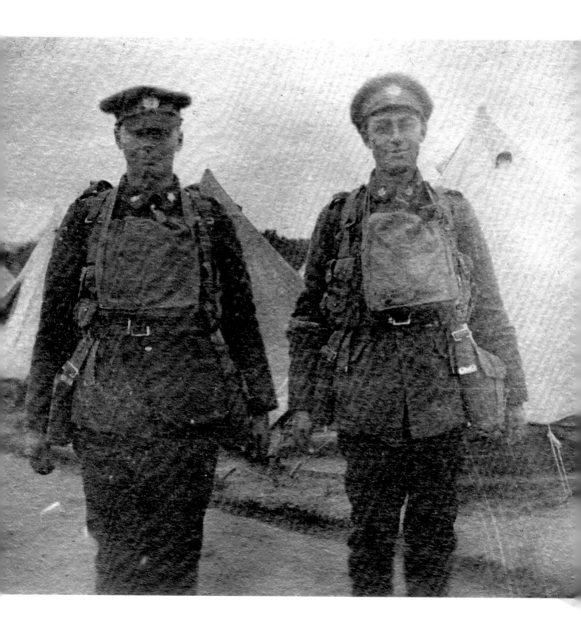

Cub and Len at in Saint-Jean-sur-Richelieu, Quebec, in full kit including a 1917 issue gas mask. (P27-MS1A1-49)

Off to War

The impact of the First World War, fought hundreds of miles away, is still visible in Havelock. The community's granite cenotaph, commemorating the dead from the First and Second World Wars, stands in front of the Anglican Church in the heart of the village, where it was erected in 1921. Over 59,000 Canadians never returned from the First World War, including eleven of the fifty-one men who signed up or were conscripted in Havelock. Len and Cub were two of the lucky ones who returned home.

When Len received his call-up papers in April 1918, the last year of the war, it would have been a jolt to his relatively peaceful and quiet wartime experience on the home front, where Len worked in the Mercantile as a clerk and chauffeur.

There are several possible reasons why Len may have chosen not to sign up voluntarily. He was employed at the Mercantile, and his father had finally succeeded in buying back the store from the S.H. White Company of Sussex in December, 1915.[1] Len would have been integral to the operations of the store as a trusted family member—his older brothers had left and set out on their own, making him now the oldest son at home. Len was also beginning to establish his own business. Photos of an Armistice parade (p. 103) taken in mid-November 1918 indicate that prior to

being conscripted, Len was already developing the garage that he would open on his return to Havelock.

Len's relationship with Cub provided another reason to stay in Havelock. Cub was younger than Len and did not reach the official enlistment age of eighteen until 1918. Cub could have lied about his age, as many young men did, and he and Len could have joined together, but clearly they were reluctant to do so. The photos show car trips in the countryside, picnics together, and nights spent in the hunting lodge on the Canaan River or at the tarpaper shack. Perhaps they were in no rush to break this idyllic time together. With some of their friends away at war, they had more time to spend alone without anyone being the wiser.

Like other small communities in the Maritimes, Havelock did its bit to help "king and country" at the front. The *Kings County Record* reported on various patriotic dinners and fundraisers held in the village. Women's Institute (WI) members busied themselves knitting wool socks, which were desperately needed by Canadian soldiers. These soldiers were not only fighting the enemy but also a condition called trench foot caused by muddy trench water constantly seeping into their boots. By late September 1914, only a few weeks after the start of the war, the WI had already raised $32.45 (about $764 in today's currency) for the Hospital Ship Fund.[2] As pillars of the community, Len's parents Agnes and Hilyard attended numerous events, with Agnes even working as a committee member for a reception to honour the enlisting men of Havelock in 1916.[3] Agnes's sister, Mrs. Glorana Fownes, held patriotic knitting circles at her house, and on at least one occasion she and Agnes helped the girls of the Red Cross put together Christmas boxes for the soldiers.[4]

Overall, the village of Havelock remained relatively calm throughout the war except for one incident. In October 1915, two Havelock women visiting Saint John were arrested for talking "seditiously" after making disparaging remarks about the British Navy. They were even suspected of being German spies but eventually were cleared of any charges. The event, however, caused considerable alarm.[5] The whole of New Brunswick was still on high alert after a railway bridge in nearby Vanceboro, Maine, had been blown up that February by German spy Werner Horn.[6]

Several recruitment drives were held in Havelock, but Len was not persuaded. This is not to say that other Havelock residents did not heed the call. In November 1915, when eleven Havelock men joined the fight, the *Kings County Record* proclaimed, "[n]o longer can the Parish of Havelock be reproached with the part she is playing in the great world's drama." This boast from the *Record* hints at the struggles to recruit young men in villages like Havelock. Around 72 percent of the

MILITARY SERVICE ACT, 1917.

IMPORTANT NOTICE.

Every male British subject resident in Canada who was born on or since the 13th day of October, 1897, and who was unmarried or a widower without a child on the 20th day of April, 1918, must report to the Registrar or Deputy Registrar under the Military Service Act, 1917, of the district in which he resides, on or before the 1st day of June, 1918, or within ten days after the man reporting shall have attained his nineteenth birthday, whichever date shall be the later. The report must be in writing, and it must state the name in full, the date of birth, place of residence and usual post office address of the person reporting. It may be sent to the Registrar or Deputy Registrar by registered post, free of postage. The address of the Registrar or Deputy Registrar to whom the report should be sent may be obtained from any postmaster. Failure to comply with these requirements will be visited by severe penalties.

ISSUED BY THE DEPARTMENT OF JUSTICE, MILITARY SERVICE BRANCH.

OTTAWA, 17th MAY, 1918.

Military Service Act, 1917.

population was rural, and in Kings and Albert Counties around 94 percent were New Brunswick-born and arguably had looser ties to the British Empire, unlike other areas of Canada with more recent British immigrant populations.[7] The Keith and Coates families had emigrated generations before and were now well settled on their land. Havelock was a strong agricultural community, and Canada needed its farmers to produce food to feed the nation and to be shipped overseas. Young men were critical for the running of the family farm, but as the war dragged into its second winter, many young farmers evidently felt the pressure to enlist.

The arrival of conscription as part of the War Measures Act in 1917 caused consternation among Canadians. More soldiers were needed: the Canadian Corps had seen the number of volunteer recruits dwindle, France's army was in mutiny, the Russian Revolution was in full swing, and the Americans were slow to join the allies in the fight.[8] At the outbreak of war, a patriotic fervour and excitement had seized many healthy Canadian men of enlistment age, but with time these feelings had eroded and recruitment drives were no longer pulling the numbers needed.[9] There was strong opposition to compulsory military service, especially in Quebec, where many felt little empathy for either Britain or France, let alone a sense of

Recruitment poster. (Archives of Ontario)

civic responsibility toward nearly three hundred years of colonial and imperial connections.[10]

These concerns were also reflected in the minority francophone population that made up roughly 28 percent of New Brunswickers. The Acadian Catholics generally had large families, and the man of the house could not abandon his family, especially if he might never return. As the conscription crisis loomed however, many Anglo-Protestant New Brunswickers looked askance at the frictions that had played out between Ontario and Quebec, leading them to label francophones as slackers.[11]

Starting in October 1917, single men between the ages of twenty and thirty-four were ordered to report to the military or to a local tribunal to plead their case for exemption, where they were then split into categories. Len was required to undergo a medical examination in Petitcodiac, possibly because he appealed on the grounds that he was a clerk for the Mercantile and was needed by his father. However, in December the government decided to do away with tribunals. Only farmers, the next of kin of serving soldiers, and the physically unfit were exempt. Len could no longer avoid going to war.[12]

After receiving his call-up papers, Len reported for duty on April 30, 1918, in Saint John, and was drafted into the army as a private. Once training began in early May in Saint-Jean-sur-Richelieu, Quebec, he transferred to the Canadian Engineers and became a sapper — a soldier responsible for military engineering duties such as fixing or breaking roads, repairing trenches, tunnelling, and other duties. Len's understanding of vehicles would have been considered a valuable asset for the Canadian Engineers and he may have swayed Cub to join the engineers, as the younger man signed up on May 16, only two weeks after Len had left town. Cub had just turned nineteen and could decide to join the army on his own terms rather than be conscripted, which had a minimum age requirement of twenty. Cub's motivation is not documented, but it is highly probable that, along with intense social pressure to enlist, Len's departure must have greatly influenced his decision to join up.

Photos attest that they were able to train together in Saint-Jean-sur-Richelieu. By 1918, the mobilization and training of troops was running like a well-oiled machine and photos show Len and Cub training together. These photos show something of the lighter side and downtime of the intense training.

The First World War was arguably the first major conflict largely documented not by professional photographers or artists but by amateurs such as servicemen. The idea that the taking of photos was a candid, friendly, even normal act during an incredibly stressful time is a direct counterpoint to the usual function of wartime photography as a tool of propaganda.[13] However, military authorities were quick to clamp down on mass photography on the front lines, limiting access to journalists. Service members in the British Expeditionary Force and the Canadian Expeditionary Force could be court-martialed if they were found to be carrying a personal camera due to fears surrounding espionage,[14] and this is the likeliest explanation as to why Len's photos of his fellow soldiers ended after he left Saint-Jean-sur-Richelieu in the summer of 1918. But Len's candid snapshots of Cub and their military chums depict great camaraderie and the conditions of their training.

Len sailed to England at the end of June 1918 and arrived in mid-July. Upon arriving, he became part of the 2nd Canadian Engineers Reserve Battalion (C.E.R.B.) and in early August was transferred to the 3rd Canadian Engineer Reserve Battalion in Seaford on the south coast. From mid-July to September, Len would have been

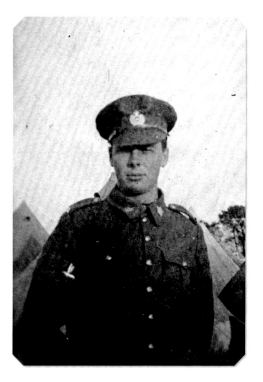

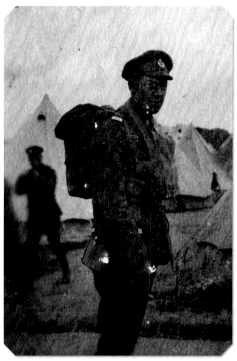

(left and above) Training camp photos of Len and Cub at Saint-Jean-sur-Richelieu, Quebec, c. 1918. (P27-MS1A1-50, P27-MS1A1-48)

(below) During military training in Saint-Jean-sur-Richelieu, Quebec. (P27-MS1N1-61)

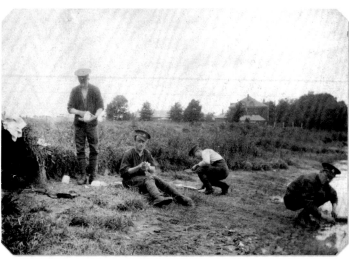

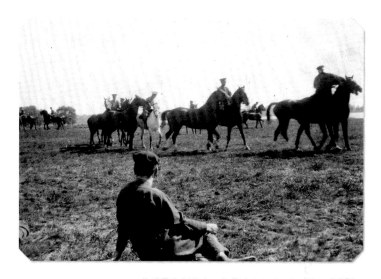

(above) Cub watching the horses at Saint-Jean-sur-Richelieu, Quebec, c. 1918.
(P27-MS1A1-114)

(right and below) Len at Saint-Jean-sur-Richelieu, Quebec, c. 1918.
(P27-MS1A1-4, P27-MS1A1-144)

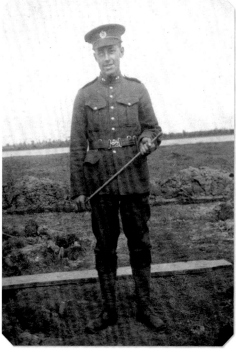

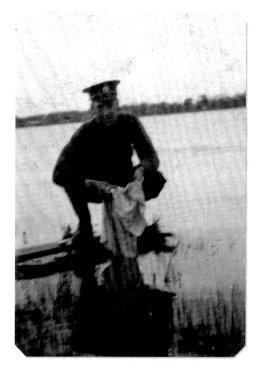

training and preparing to go to France. As for Cub, he left Saint-Jean-sur-Richelieu and arrived in England on August 15. Although both Len and Cub were at Seaford at the same time, it is unknown how much they would have seen of each other. They may have seized any opportunity to spend time together or at least write to each other while they were stationed in separate areas, as was the custom at the time. Having a close friend from home would have been a great comfort for these two country boys far from their hometown.

Len and Cub were among the engineers sent to France on October 8, 1918, only a month before the armistice. The last stage of the First World War has come to be known by historians as "Canada's Hundred Days."[15] Canadian troops had already earned a reputation as dedicated soldiers and good fighters who were given the role of being at the forefront in such important battles as Vimy Ridge and Passchendaele. On August 8, the Battle of Amiens began, with the German army suffering great casualties.[16] A critical point was reached in what had previously been a war of attrition. From August 8 to 11, the German line was pushed back twenty kilometres, an impressive feat thanks largely to Canadian troops. By the end of September, Canadians had finally broken through the Hindenburg Line, the main line of defence of the German Army.[17]

This new style of battle against a retreating enemy required intensive support from the Canadian Engineers.[18] Equipment and armaments needed to be moved quickly and roads needed continual care, as the movement of heavy machinery, trucks, and artillery damaged them and made them difficult to navigate. According to military records, Len and Cub spent the last month of the war stationed in France with the Canadian Engineer Reserve Pool in France and remained there until January 1919. They would have been busy moving equipment and repairing roads and bridges until the end of the war and then helping with the cleanup afterwards.

In Len's collection there are four photos of a devastated village in Northern France or Belgium in what appears to be late 1918. The images are emblematic of the destruction left behind and the need for the reconstruction that would get underway after the war. Unlike propaganda images at the end of war that focus on victory celebrations, these images are quasi-austere. The photographs depict a post-war scene that was incredibly common—a village with homes destroyed—but also show the work that was going on to rebuild. The war had been the most

(opposite) Photos of the devastation of war from Len's collection of photos.
(clockwise from top left: P27-835, P27-833, P27-834, P27-836)

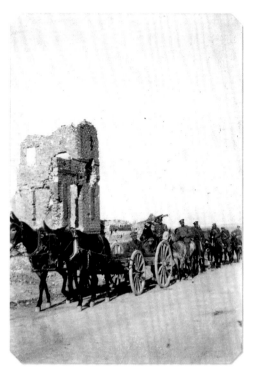

technologically advanced to date, and these images show the destruction of centuries-old homes and roads. Both lorries and mules are captured by the camera, a temporal tension where the nineteenth and twentieth centuries met. A lorry passes down a road, while the foreground shows a field of debris where there used to be a living, breathing, healthy community. These photos are not marked on the back, so it is unknown if they were part of a series taken by a photographer at the end of the war and sold to the troops who wanted to remember their service or by a friend of either Len's or Cub's.[19]

In late January 1919, Len arrived at a Canadian Concentration Camp,[20] a camp where a large group of Canadian soldiers were gathered. He was then sent back to England to await demobilization to New Brunswick. Cub, on the other hand, was transferred at the end of February 1919 to the 3rd Canadian Infantry Works Company (C.I.C.W.) located in Huy, Belgium, moving towards the community of Waret-l'Évêque. According to C.I.C.W.'s war diary, their days consisted of guard duties at Huy and Ardennes, inspection parades, and drill. In March they were required to help the Canadian Cavalry Brigade near Namur with "Horse Conducting Duty"[21]—meaning that horses were being moved to other parts of Belgium, a task that would have suited Cub and his love of horses. The company moved on to Ardennes at the end of March, where they helped to move artillery across northern France by train.

Finally, on May 7, they began a long two-day journey by foot to Étaples, France, marching through Calais at night and arriving at the Canadian General Depot at four in the morning. This was the first step to going home. Cub left France for England with 150 of his comrades.[22] The toll of the physical labour must have been extremely difficult, as Cub had a strained nerve in his right shoulder when he returned to England. Yet Len and Cub were fortunate compared to many. They survived the war, as well as the Great Influenza pandemic that spread quickly through trenches, barracks, and military hospitals.

. . .

The story of Len and Cub is not just a rare example of an early documented queer relationship in New Brunswick (and in Canada). It is also an extremely rare documented example of a homosexual relationship during the First World War. The photos of their time training in Saint-Jean-sur-Richelieu may be the first known visual records of a Canadian same-sex couple who participated in the First World War together. The fact that we have been able to glean any details of how their relationship was able to occur in the time and place that it did before they went off to war is remarkable in and of itself. What makes it even more significant is that, by observing their war records, Cub volunteered, following Len after his boyfriend was conscripted. Beyond brief studies of famous homosexuals of the time, such as war poet Wilfred Owen, very little has been written about homosexuality among the ranks of First World War soldiers.

The war caused a large disruption in traditional social structures and thus offered opportunities for both men and women to explore new sexual experiences.[23] Men who were thousands of miles from home needed the emotional support that wives and girlfriends usually provided, and many turned to prostitutes for sexual and emotional relief. Venereal disease skyrocketed, and military officials did their best to cover this up and preserve the pure and moral image of their troops.[24]

In the trenches men often took on more "feminine roles,"[25] helping each other cook and clean, providing emotional support, and sharing intimate confidences under the guise of comradeship. Another less serious but beneficial release that was permitted was crossdressing for comedic purposes. Groups like The Dumbells (page 90), a Canadian theatrical troupe that dolled themselves up in drag and entertained the troops, became popular at the time.[26] Military authorities tolerated this as entertainment for soldiers who had experienced the hardship of war.

The war threw together millions of men of different classes, ethnic origins, and religions from around the British Empire with a common goal of fighting the enemy. In this male-dominated, life-and-death environment, tight male bonds developed, and such a large concentration of men would have most certainly provided some with same-sex experiences either in camp or on leave. As historian Jason Crouthamel states, "the war did not create homosexual behaviour, but rather this environment facilitated relations between homosexual men who were otherwise repressed before the war."[27]

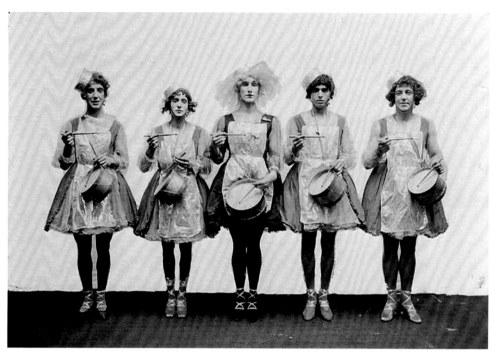

The Canadian war-time theatrical troupe, The Dumbells, 1917–19.
(Canada. Dept. Of National Defense / Library and Archives Canada, PA-005741)

One of the only books that documents homosexual soldiers of the British Empire is *Fighting Proud: The Untold Story of the Gay Men who Served in Two World Wars* by Stephen Bourne. Bourne writes that around 22 officers and 270 men in the British forces were court-martialed during the First World War for actual or attempted indecency or indecent assault; that is, sexual or intimate contact with another man. Considering the millions who served, Bourne notes, this is a low figure.[28] These cases show that men acted on their same-sex desires during wartime but do not take into account the number of men who may have had consensual sex with men or who "sublimated" their desires for fear of persecution.[29] Due to the cramped quarters in barracks and at the front, Bourne is certain that soldiers must often have masturbated in front of each other and that monogamous same-sex couples who were private about their affairs were tolerated in some ranks. The non-commissioned ranks would have been made up of soldiers from tight-knit, working-class communities who probably had some understanding and sympathy for men who sought sex with other men as long as they were not predatory.[30]

It is impossible to know how many men would have had same-sex desires for other men. There were a few court-martial cases for "indecent conduct" in the Canadian Expeditionary Force, but they were written up using cold, strict legal terms and in some cases have been coloured by the views of witnesses who would have viewed such things with hostility. They are void of any sense that the accused parties may have felt affection for one another. In one case, Private Emile Charette of the 10th Battalion was charged under Section 18 of the Army Act (a catch-all clause for various disciplinary offenses), found guilty of committing an act of gross indecency with his friend Private Trempe when they were in camp at Shoreham-by-Sea in 1917, and imprisoned for nine months. They had gone back to Charette's hut one evening, and another man, Private Addison, who had been on leave, came back to the hut to find them on his bed, and witnessed Charette performing fellatio on Trempe. There were inconsistencies in the accounts from all parties, and Charette relied on the excuse that he and Trempe had been drinking. Another soldier reported Addison shouting "that he would not stand these dirty things any longer" before he stormed off to find the Military Police. Addison may have been making reference to the fact that this was not the first time Charette and Trempe had engaged in this kind of sexual behaviour, hinting at a long-term relationship. Some of the other soldiers in the hut were clearly not bothered by Charette's and Trempe's actions; one soldier made sure that Trempe returned safely to his own hut before the military police came.[31]

In another case at Shoreham-by-Sea, Private Romeo Belisle of the 2nd Quebec Regimental Depot was found guilty of gross indecency after he and another soldier were caught in a latrine together. According to Belisle, the other soldier followed him into the latrine to see if he was able to exchange some Canadian money for British currency. The soldier testified that Belisle offered him two shillings to have sex with him. Other soldiers, who had seen the two men entering the latrine, feared that their comrade was in danger and rushed to get the Lance Corporal and Corporal. When the Lance Corporal arrived, he peered into the latrine and heard Belisle say, "Come on and suck it." The other soldiers, who had started to gather around the door of the latrine, began pelting it with rocks and shouting for the men to leave.[32] This reaction from the men echoes Bourne's argument that soldiers were less tolerant of those who preyed upon other men for sexual gratification.

Accusations of gross indecency could also be used for personal gain or to humiliate another soldier. In the case of Lieutenant Hugh Pope-Hennessy, rank and status did not prevent him from being court-martialed under Section 16 of the

Army Act for "scandalous behaviour unbecoming to an officer" on the front lines in Neuville St. Vaast in January 1917. Hugh was the son of Sir John Pope-Hennessy, an Irish politician who had been Governor of Hong Kong and later of Mauritius, where Hugh was born. Lieutenant Pope-Hennessy was the "Town Major," the officer responsible for billeting troops and general sanitation in a town where troops were garrisoned. He slept in a dugout with a private who acted as a runner in emergencies. In 1917, Pope-Hennessy was sent a new runner, Private Flack, from a different battalion. According to Flack, a few nights later, Pope-Hennessy asked him if he could warm up in Flack's bunk with him for a few minutes. Flack agreed, but said that Pope-Hennessy then placed his hands on Flack's privates for around ten minutes before getting out of the bunk and back into his own. Flack reported the incident to the adjutant and left the next day. Pope-Hennessy denied the entire story and claimed that Flack might have made it up in order to be sent back to his previous battalion. The court found some inconsistencies in the timings in Flack's allegation. Combined with Pope-Hennessy's denial, good references, and the testimony of his previous runner that he had never been assaulted, the evidence was not enough to convict Pope-Hennessy. He was acquitted but died in late April 1917.[33]

Two good friends, Lance-Corporal Watson and Private Grant, attempted to entrap Orderly Room Sergeant Ernest S. Keeling of the 1st Reserve Battalion in Seaford, the same camp where Len and Cub would end up in the summer of 1918. Watson disliked Keeling for reasons that are not entirely clear. The orderly room was a busy place, and Keeling expected his men to work hard. Private Grant, a telephone operator, had fallen asleep on the job before, so that evening Keeling had him come to his room to make sure he was still awake and on duty. According to Grant, Keeling allegedly rubbed Grant's penis and directed Grant to rub his. Grant had been set up by Watson to do this to get proof that Keeling was capable of indecent conduct. Watson's motivations are unclear, but he had apparently had his own encounter with Keeling a few weeks before, and although he did not describe what happened, he said "I thought that if he was the man I had found him out to be he had no right to be running around."[34] Even Keeling's exemplary war service and Meritorious Service Medal could not save him from this allegation. He was sentenced to 18 months in prison and stripped of his non-commissioned officer status.

These records are important for our understanding of same-sex desire and experiences that took place over 100 years ago. While punishments varied depending on the severity of the offence, the humiliation a soldier would feel must

not be forgotten, especially in the case of Sergeant Keeling, who was reduced to being a regular private after being found guilty. The number of cases that were covered up for the good of unit morale by officers, as was common in the Second World War,[35] is unknown. Whether Len and Cub saw each other during their service or had relationships with other soldiers is not known. Letters, if there were any, have been lost or destroyed, but they were in an environment that both fostered same-sex desire, albeit at the risk of court martial and disgrace.

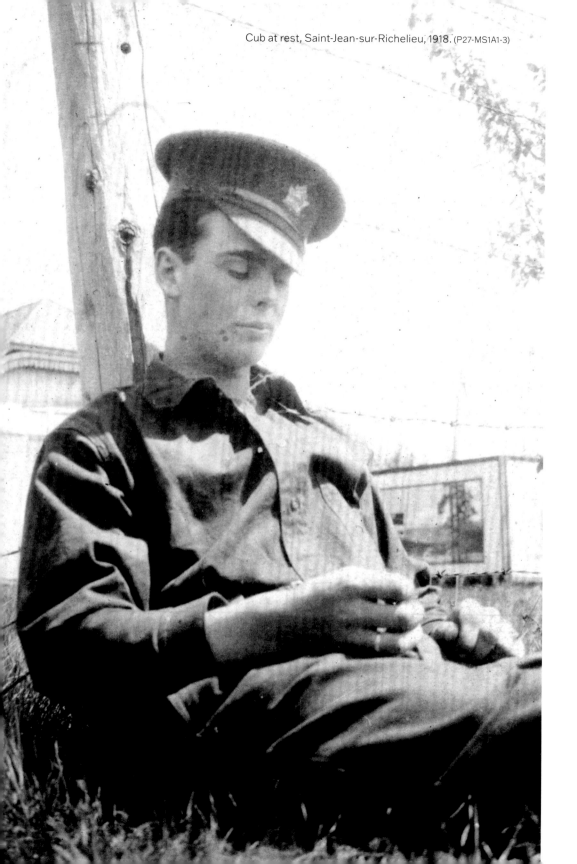

Cub at rest, Saint-Jean-sur-Richelieu, 1918. (P27-MS1A1-3)

Len, Saint-Jean-sur-Richelieu, 1918. (P27-MS1A1-2)

Unveiling of the War Monument in Havelock, August 1921. (P27-421)

"A Devil in His Own Home Town"

The demobilization of soldiers was a lengthy process. Many thousands needed to return to Canada, and soldiers became restless with the "hurry up and wait" methods of administrative officials. Cub returned before Len, leaving on the S.S. *Baltic* from Liverpool and arriving in Halifax on July 8, 1919. He was officially discharged on July 11. Len followed later, leaving England on September 6 from Tilbury. He arrived in Halifax on September 14 and was discharged on September 20.

During the last week of August, a celebration was held for the Havelock boys and nursing sisters who had returned by then. A baseball game was held between Havelock and the nearby town of Cornhill, followed by a picnic and speeches delivered at the public grandstand. J.D. O'Connell, a Havelock native who spent his life in various business endeavours and became known as the "Summertime Santa Claus,"[1] attended the picnic and threw fifty dollars in pennies into the crowd for the local children. A meeting was held at the Public Hall that evening with Hilyard presiding as host. "Leonard A. [sic] Keith"[2] was listed as one of the boys who had not yet returned from England, along with Roy Corey, John Corey's father and a friend of Len and Cub.

Len and Cub in their work clothes, c. 1920s. (P27-MS1F1-144)

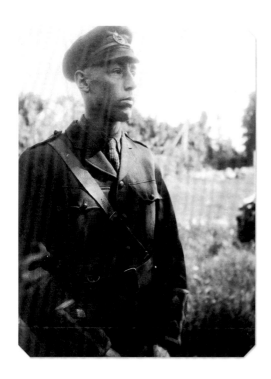

Len in Lieutenant's uniform of the 8th Hussars Militia unit. (P27-MS1F1-4)

The war was over and the residents of Havelock settled into the new normal. Many loved ones had died in battle or from the Spanish Influenza. Neither Len nor Cub would ever travel so far from Havelock again. They would have seen first-hand the impacts of the war: the destroyed villages, the devastated farmlands, the suffering civilians, and of course the numberless dead. After major world-altering events, life is never the same.

With the end of the war and Len and Cub's return to Havelock, a new phase in their relationship slowly began to unfold. They continued to spend time together and enlisted in Princess Louise's 8th Hussars militia unit in Sussex, the oldest cavalry regiment in Canada. Given his previous training and experience as a veteran of the Western Front, Len was made a provisional Lieutenant in 1922.[3] The training usually involved a nine-day summertime stint at Camp Sussex. Cub may have been attracted to the militia by the chance to work with horses, and he was active in the militia until the late 1920s, earning the rank of Lieutenant in 1924 and then Captain in 1928.[4] Working with horses in a military setting required great patience and coordination, as manoeuvres needed to happen swiftly and flexibly.[5] In contrast to Cub's lengthy service, Len would leave the militia in the summer of 1923 when he moved temporarily to Portland, Maine.

. . .

By the early 1920s, owning an automobile was becoming increasingly affordable. Len, with his great interest in cars and some business savvy, must have sensed this wave of change. Following the war, he opened his own garage, built around 1918, to serve the people of Havelock and the surrounding area. Hilyard must have given Len the land for the garage, as it was built behind the Mercantile, and there are no deeds in Len's name. Meanwhile, Cub returned to farming with his father, but he was still able to help Len around the garage as a mechanic and in the 1921 census is listed as working there. Over time, the photos show that Len made updates to the garage, adding pumps for gas and oil and doors on either side of the carport, along with signs advertising cold drinks and Goodyear tires.

Even though automobiles were becoming ever more popular, rural Havelock may not have seen the boom in motor traffic in the 1920s that it experienced by the 1930s and 1940s, so Len was forced to branch out business-wise. Besides servicing cars, he quickly thought of other ways to make money. He arranged for the garage to become the local pool hall and hangout for the men of Havelock, where "vices" such as alcohol and tobacco would have been readily available. As some older Havelock residents recalled in the book *Butternut Ridge-Havelock: Our Proud Heritage 1809-1989*, "Pay day was a momentous day in Havelock. $12.00 bought a lot of bootleg liquor. At that time, Len Keith had a service station where Roy Cosman's Garage now stands. Ice cream, cigarettes and chocolate bars could be purchased there. None of these men had cars but for one day in the month they were big spenders."[6] As a veteran, Len would have been considered a role model, and it can be imagined that some villagers would not have been thrilled that he had opened a pool hall where local boys could have access to such vices as drinking and most likely gambling.

A 1914 ragtime song by Irving Berlin, "He's a Devil in His Own Home Town," exemplifies Len and his pool hall perfectly, as if it had been written about him:

> He's got a reputation in the village,
> Known as a dude, a gosh darn dude
> He would never do in New York City
> But in his home town.
> He's a devil, he's a devil
> He's a devil in his own home town.[7]

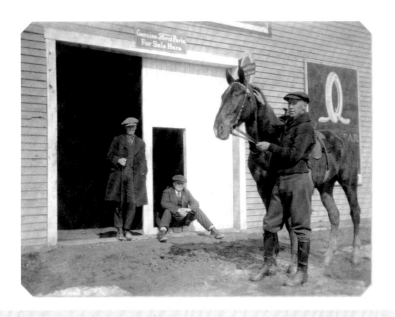

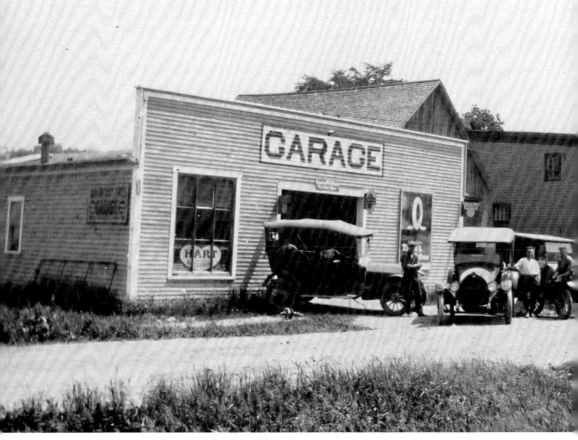

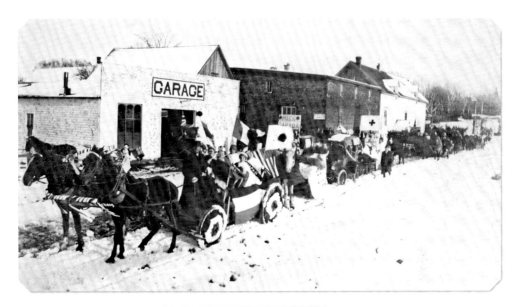

(clockwise from above)
Armistice Day Parade in
Havelock, with Len's garage
visible in the background,
November 1918. (P27-1-320)

The garage after some
upgrades, including painted
siding and advertisements
for brand name tires,
tubes, and batteries.
A second display window
has been added to the right
side of the building. (P27-22)

Cub (left) and Len (with
horse) c. 1920-1925.
(P27-MS1F1-83)

(below) "GARAGE" has been painted over as Len begins transitioning his business into a pool hall. (P27-768)
(opposite) The garage festooned for a Dominion Day party. (P27-MS1C1-81)

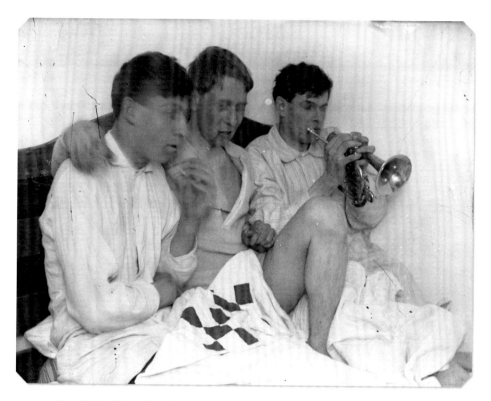

Len (left) with brothers Fownes and Robert at the Keith family home. (P27-238)

The surviving images of Len suggest that he had a kind and gentle nature. Whatever sort of illicit operation he was running in Havelock, he was definitely not a thug. Ever the entrepreneur, Len updated his business multiple times over the years, first adding a pool table and refreshments and later on fresh coats of paint, lights, signage, and additional pumps.

The story of young men splurging on payday at Len's garage is revealing about the nature of Len's operations in the 1920s. Alcohol had always been a divisive topic for New Brunswickers, especially given the large, strict Baptist population of places like Kings County. In the nineteenth-century, alcohol was often safer and more readily available than drinking water, and Maritime labourers often received a rum ration for their hard physical work. This helped contribute to a dependence on alcohol over time. Against this backdrop, the Sons of Temperance established their first New Brunswick chapter in St. Stephen in 1847. The organization worked hard across the province to preach abstinence and condemn what it viewed as the ills of drink

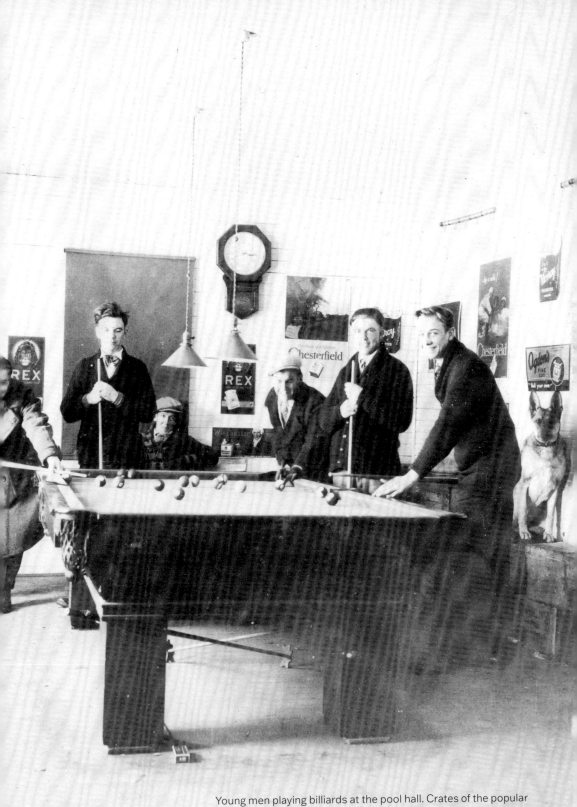

Young men playing billiards at the pool hall. Crates of the popular Evangeline Ginger Ale are stacked up beside the wall. (P27-MS1F1-168)

Kings County youths posing in front of the garage/pool hall, c. 1930. (P27-613)

as well as the poverty it caused and the crimes that were committed by those under its influence. Large portions of Protestant New Brunswick, including Kings County, went dry in 1878 under the Canada Temperance Act, also known as the Scott Act after its creator, federal politician Sir Richard William Scott.[8]

Struggles over temperance affected everything right down to municipal politics. The *Kings County Record* noted in 1895 that an unspecified "Mr. Keith" (most likely Hilyard, a strong Conservative who had been a former town councillor) had run for office unsuccessfully on a platform in opposition to the Scott Act in a previous election. The newspaper reported that the parish had sided with those in favour of temperance.[9] Hilyard would have been a licensed vendor able to sell alcohol "for medicinal purposes" in the Mercantile, so it makes sense that he would advocate broadening the sale of alcohol.

Young Len (right) and friend c. 1910-1915. (P27-233)

Orders of alcohol could be placed by vendors from legal wholesalers in Montreal or Saint John. The vendor could then quietly turn to "bootlegging" and sell liquor on the side to those looking for it.[10] Families could also order liquor from Quebec and outside of New Brunswick for personal or family use. The fact that the Keith family was ordering in liquor is evidenced by a number of photos taken by Len during his youth which feature brown jugs and bottles of gin and scotch. Because of the Keith family's standing in the community, a blind eye may have been turned by the local magistrates.

The Provincial Liquor Act of 1916 decreed total prohibition and was in effect from 1917 to 1927. As part of the War Measures Act, in 1918 all of Canada except for Quebec went dry as well.[11] After the War Measures Act was lifted in 1920, the New Brunswick government held a plebiscite on whether or not to keep prohibition. Those supporting temperance won. This led to the development of a massive black market operated by moonshiners, bootleggers reselling illegally obtained liquor, and "rum-runners" who moved alcohol across the province and from Quebec to Maine. Disputes sometimes resulted in shootouts between rum-runners and police. As historian B.J. Grant wrote in his account of prohibition in New Brunswick:

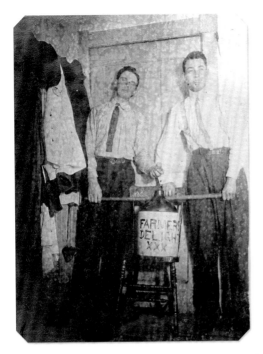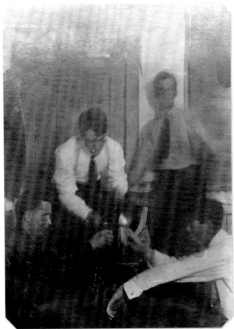

Cub and Len with a comically large jug of hootch or moonshine labeled
"Farmer's Delight XXX," which they then share with friends.
(P27-MS1O1-183m, P27-MS1O1-184)

The bootlegger and the moonshiner were fairly innocuous; but the men who ran the rum, the self-styled daredevils who sped across the province and the border in the powerful cars, who flashed fat rolls of cash when all about them was so much poverty, those who sported their "molls" and swaggered in fine clothes and boasted that they always "packed a rod"—many of these were thoroughly dangerous.[12]

Len understood the power of alcohol not just as an intoxicating substance but also as a means to turn a profit. Indeed, people were running stills in every community in New Brunswick. Even with its large Baptist population, Kings County was no exception, with moonshiners often resorting to using a cream separator as a simple still.[13] With his love of alcohol and his need for business, it is unlikely that Len's garage and pool hall went "dry" during this period. Len drank from a young age and eventually succumbed to liver cancer. It would not have been surprising if he had relied on homemade brew to sell to the thirsty young men of Havelock.

Len was focused on improving his business at home after returning from the war, but in 1923 he decided to move to Portland, Maine.[14] The exact motivation for his move is unknown, but he ended up working at the Portland Automobile Sales Co. It could be that Len was responding to the boom in automobile production and sales in the United States. Over the two decades from 1910 to 1930, automobile registrations ballooned from around 458,000 to around 22 million. Portland, like other American cities, began to see automobile showrooms like the Portland Automobile Sales Co. spring up on main thoroughfares.[15]

By contrast, economic conditions in the Maritimes were dire in the 1920s and 1930s. The fishing and mining industries were struggling, and entrepreneurs trying to establish new manufacturing industries were having great difficulty breaking into the Canadian market even with subsidies to transport their goods.[16] There was a significant level of out-migration to both the United States and Western Canada from the Maritimes. Whether Len wanted to extend his knowledge of working with cars or simply craved a new adventure, Portland promised better economic prospects than Havelock at that time.

Records show that Len arrived in Portland in July 1923 and began working at Portland Automobile Sales Co., possibly as a mechanic or sales clerk. Len's life in Portland remains a mystery except for a number of photos of frequent visits to Deering Oaks Park, a kilometre away from the Bayside neighbourhood where he boarded at a three-storey rooming house on Cumberland Street. Interestingly, this park has long been known as a gay cruising area. A 1996 report from *Casco Bay Weekly* notes that "for decades, Deering Oaks was the gay cruising spot in Portland. In spite of assaults, robberies and occasional police crackdowns, the park was a nationally known magnet for those seeking sexual partners."[17] Len had a social circle there and was quite close to a few men in particular. Photos show him posing playfully with various men in Deering Oaks Park, and a few of the photos include groups of men seated together in the background. The Portland directories have him listed as living on Cumberland Street in 1924 and 1925, and Len may not have returned to Havelock until the winter of 1926.[18]

We know that Len and Cub remained in contact during Len's time in Portland thanks to a report in *The Moncton Transcript* in May 1924 that Cub visited Len for a week in Deering Oaks Park.[19] However, Len and Cub's relationship in Havelock could never exist openly outside of that of friends and former comrades-in-arms, since living openly as a gay man during the period was perceived as a legally and morally improper lifestyle. Moreover, Len would have undoubtedly attracted

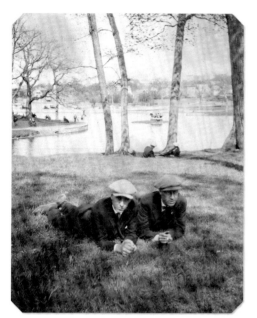

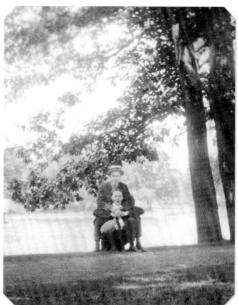

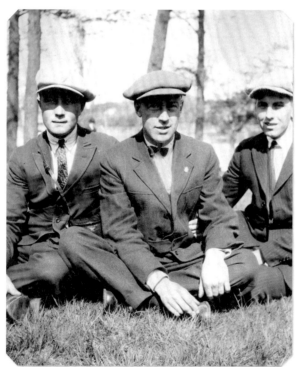

Len and friends at Deering Oaks Park, Portland, Maine.
(P27-MS1F1-87, P27-MS1F1-57, P27-MS1F1-86)

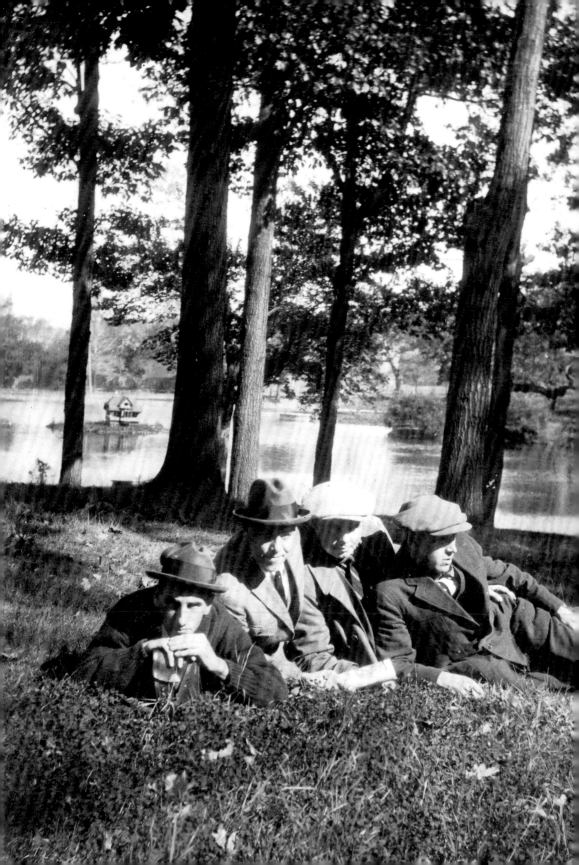

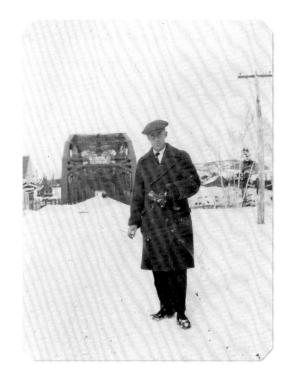

(right) Len with his Kodak camera at a border crossing from Maine to New Brunswick, 1926. (P27-MS1F1-91)

(opposite) Deering Oaks Park, Portland, Maine, Spring 1924. Cub is second from the right, with his hand resting on Len's thigh. (P27-MS1F1-58)

attention in Havelock, since his garage had become a haunt for the local men where they gathered to play pool, purchase refreshments, and socialize. Prohibition was still in effect in New Brunswick until 1927 (and would remain in force in the United States until 1933), but both Maine and New Brunswick were well furnished with illegal stills. The promise of a lucrative career in Maine, away from prying eyes, would have provided a tempting alternative for this young entrepreneur.[20]

Back in Havelock, Hilyard was getting older, and although he wasn't ready to surrender his beloved Mercantile, it would not be surprising if Len was compelled to return home to give him a hand. Hilyard had an immense passion for his store. He worked until the day he died, quite literally, dying suddenly from a heart attack in his office at the store on February 15, 1928, at the age of 65. His obituary described him as being "held in the highest respect and esteem throughout the community."[21] Mrs. Hicks, the wife of the local undertaker, kept a detailed diary of all the deaths in Havelock and noted that Hilyard had suffered from a leakage around his heart for some time.[22] With Hilyard's passing, Len, Lucy, and Agnes were left to run the store.

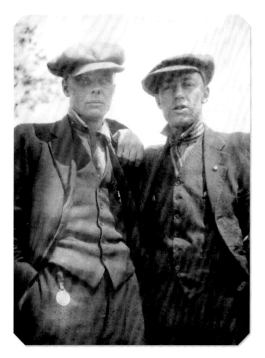

Cub and Len, c. 1926. (P27-MS1F1-50)

Our only window into Len's life after his return to Havelock, are two photo albums. Cub appears less and less frequently in these photos and Len seems to start spending more time with other young men: going on camping and fishing trips; visiting the beach; and even travelling on the *Majestic*, the last steam-powered boat to operate on the Saint John River (Wolastoq).

Was there a turn in their relationship, or even perhaps a parting of ways? Had their friends or other villagers begun to take notice of all the time they spent together? Or did the relationship simply run its natural course? Cub was now in his early twenties and taking on more responsibilites, having been given a farm as part of the Soldiers Settlement Board program.[23] Len and Cub's could no longer be seen as simply a close boyhood friendship. As they aged, men were often expected to adopt a more competitive and less affectionate relationship with each other. There was less room for plausible and socially acceptable deniability as to the nature of their relationship, let alone to the nature of the men themselves.

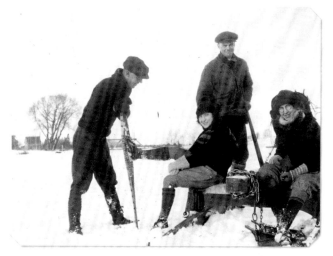

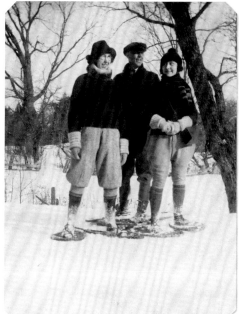

(above and left) Len with his sister Lucy, Cub, and a friend. (P27-MS1F1-68, P27-MS1F1-62)

(below) One of the last photos of Len in Havelock, 1931. His companion is unknown. (P27-913)

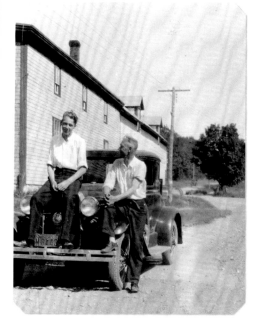

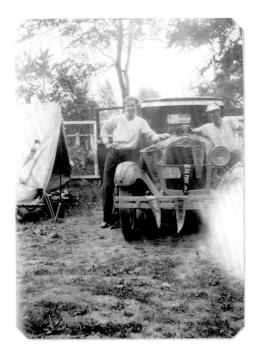
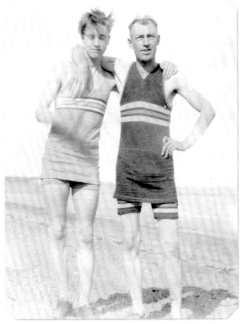

(clockwise from top left)
Len's car draped with pennants from pit stops in Quebec en route to Toronto
for the Canadian National Exhibition. (P27-MS1C1-14)

Len with mystery companion, c. 1928. (P27-MS1C1-52)

A "Night in Harlem" jazz show at the Canadian National Exhibition,
Toronto. (P27-MS1C1-47)

. . .

In August 1929, Len decided to drive to Toronto to take in the Canadian National Exhibition. He had an unnamed travelling companion who appears throughout this last Kodak album, and based on the photos, Len and this companion spent a great deal of time together. The young man looks like he is in his early twenties and is identifiable throughout the album. The two men stopped and camped along the way, travelling through Grand Falls, New Brunswick, and Lévis, Quebec. Visiting the big city of Toronto would have been a great adventure for these rural New Brunswickers. They explored the downtown, wandered around the Exhibition, took in the fair and the gardens, watched fireworks, and attended a musical review called "Night in Harlem" featuring Black jazz musicians and dancers from New York.

Len's photographs from his trip are similar in style to those he took over a decade earlier with Cub. Yet again, we see the same pose repeated by Len and his partner to create dual portraits, as well as photographs of Len with his arm around his companion. But there are no more surviving photographs of Len and his companion following the trip, and Len was quickly approaching the end of his time in Havelock.

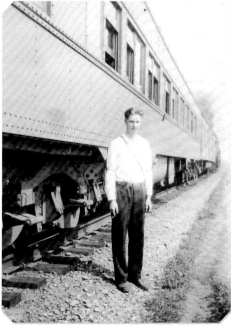

Len and his travel companion during their trip to Toronto. (P27-MS1C1-50, P27-MS1C1-49)

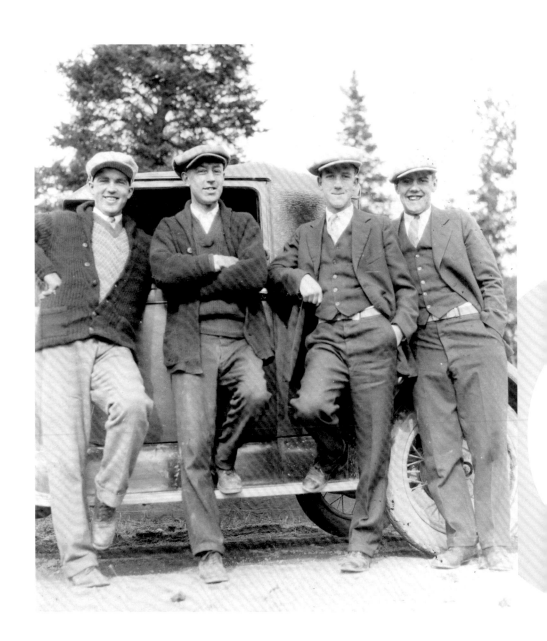

Len and Havelock lads, c. 1929-1930. (P27-MS1C1-66)

The Outing

In 1931, Len was eventually outed and forced to leave Havelock. While the villagers moved on with their lives, the story had not left people's minds or the tongues of gossips. There are still some elderly locals, born in the 1930s and 1940s, who remember being told that Len Keith had been forced to leave town because he was a homosexual.[1] The fact that Len was nearly 40, had not settled down with a local girl, and toured the surrounding countryside in the company of Cub and other young men would not have gone unnoticed by the villagers. Before they left for war, Len and Cub's road and camping trips could have been glossed over as boyhood camaraderie, but the amount of time they continued to spend together after the war, together with their obvious closeness, may have caused tongues to wag as they grew older. The details of Len's outing as a homosexual are not clear, but the information gleaned from primary sources paints a picture of what possibly transpired.

In addition to running the service station and pool hall, a new opportunity had captivated Len. Fox farming in Prince Edward Island and New Brunswick was an extremely important and competitive industry in the 1920s and 1930s, particularly in New Brunswick's Westmorland, Albert, and Kings Counties. The community of Salisbury, not far from

Havelock, still bears the title "Home of the Silver Fox," a moniker that refers to this era. Fox stoles and coats were in vogue (as well as being warm items of clothing perfect for cold North American winters), and a fox rancher could make good money from the sale of pelts. A 1928 fox farming directory describes New Brunswick as a "World Fox Centre"[2]—at a time when fox pelts were fetching their highest prices on the market, anywhere from $75 to $300 a pelt. During the Great Depression, many farmers took up fox farming. As an entrepreneur, Len too was intrigued, and fox pens started to be built around the Keith farm in late 1929 or early 1930.

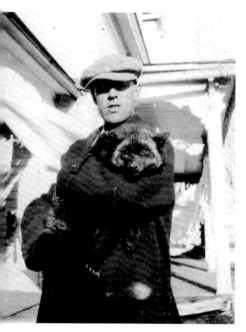

Len and Charlie the fox,
c. 1930. (P27-MS1F1-67)

Embracing fox farming may have been a double-edged sword for Len. As lucrative as it was, the competitive nature of the industry may have contributed to his outing and eventual expulsion from the village. Many of Len's neighbours were involved with rearing foxes of their own, including the Marr family. The Marrs had known the Keiths for a long time: both families traced their roots back to the Corn Hill area just outside Butternut Ridge and Hilyard's father, Charles Keith, is listed on the 1862 map of St. John and Kings Counties by H.F. Walling[3] and in the 1871 Census as living across from the William E. Marr family. William's son Niles Ellsworth Marr would have been roughly the same age as Hilyard. Niles turned to fox farming in the 1920s, with his son Percy joining him in the enterprise. Percy was seventeen years younger than Len and thus not in the same peer group as either Len or Cub, but he was of an age to hang around Len's pool hall in the mid- to late 1920s.

Len's outing as a gay man is a key element in this story, but one that requires researchers to glean small details from the few surviving primary sources. Even then, the picture that emerges is fragmented and requires researchers to fill in the gaps as best they can. Searching through sources such as the Havelock public hall record book and details about the relationships and connections between the two families offer clues as to what might have occurred.

The archivist who recorded John Corey's information about the Keith family albums included the following note with a photograph of Marr: "Percy Marr

standing outside of a house in Havelock, N.B. He was partly responsible for having Leonard Keith kicked out of town for being homosexual." Len's decision to branch out into a small and already crowded industry would have brought him into competition with Percy Marr, impacting the Marr family's fox farming profits.

The difficulty of learning why or how Len was outed perfectly illustrates a central fact of life for many queer people in rural Canada in the early part of the twentieth century. Gossip, hearsay, and subtle subterfuge are, by their very essence, hard to quantify, let alone prove. However, unlike in a court, where the burden of proof is on the accuser, outing someone in the court of public opinion transfers that burden to the accused. It is a scarlet letter with potentially dangerous consequences. Outing Len as a homosexual or "pervert" would have been advantageous for Percy, swiftly eliminating a direct competitor.

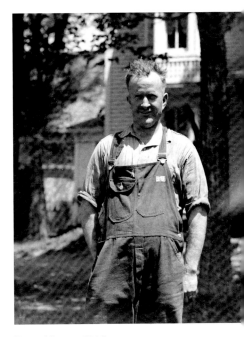

Percy Marr, c. 1940. (P27-837)

Percy Marr was just one man, and he would not have had the power to drive Len out alone. However, he was part of a group of men who must have had enough evidence to eliminate any doubt about Len's sexuality.[4] Len's role as a purveyor of alcohol through the pool hall may also have contributed to public unease over his presence in Havelock. In January 1931 Len had joined the board of the Public Hall, an institution that the Keith family had been instrumental in establishing and still held shares in. The Hall's logbook contains one entry about Len. He was appointed auditor on joining the board and tasked with collecting payment of six dollars for damages to the Hall from a group of young men who had drunkenly trashed the Hall the previous Halloween. It is unclear whether Len recovered the damages, but he may have been held partially responsible by those who disapproved of his business or attracted the ire of the young men who'd damaged the hall.

However the scandal played out, Len was forced to leave town sometime in early August. An article from August 15, 1931, in the *Burlington Daily News* reported that Len was visiting his brother Fownes, who now lived in Vermont just outside Burlington.[5] During the visit, a Power of Attorney was drawn up in which Len

signed over complete control of the finances and operation of the service station to his sister Lucy.[6] There is no record of him ever returning home again until his burial in 1950 and very few records of his whereabouts until his death.

The aspect of this whole story that may be the most shocking is that Len's outing, which took place ninety years ago, is not a thing of the past, nor is it unique to Len's generation. Around the world, queer people still face violence, discrimination, and harassment and are often the victims of honour killings.[7] The degree and manner of violence associated with Len's outing is unknown to us, but it would not be hard to imagine. Was he able to sneak away quietly in the middle of the night? Was he attacked by some of the local young men? We hope the former but would not be surprised by the latter. Len, even though he was from rural New Brunswick, was well travelled by this point. He likely understood the risks of being exposed as a homosexual, and must have taken some precautions to limit the types and measure of violence that could befall him at any time.

The interwar era saw a growing climate of violence and intolerance towards minority groups (including people of colour, homosexuals, and various religious denominations) as hate groups and nationalist organizations gained strength across North America. The Maritimes were no different: the Ku Klux Klan had a stronghold in New Brunswick during the 1920s and 1930s, fuelled by distaste and repulsion towards those who threatened the Anglo-Protestant status quo. Notable among these "threats" were Catholics and Francophone New Brunswickers, who were finally able to represent their communities politically after being held back socio-economically and linguistically.[8] The Klan appealed to "radical Baptists" and saw itself as a "chivalric force for the moral betterment of Canadian Society."[9] In contrast to its American counterpart, the Canadian Klan felt responsible for upholding what it saw as the traditions and values of British North America. They were a fervent force for temperance and raided liquor joints as well as houses of ill repute. Their tactics were violent: several New Brunswick men were murdered by suspected Klan members. Kings, Carleton, York, and Albert Counties all had a Klan presence, and Havelock was not untouched by the Klan's influence.

In August 1928, a report that a fiery cross was lit in a field in Havelock by Ku Klux Klan members was printed by the *Telegraph Journal,* but little context was given.[10] A similar event took place in Sussex roughly a week later and appears to have been part of an initiation ceremony for new Klansmen.[11] Based on rumours documented

Kings County Record, April 27, 1928.

in *Butternut Ridge-Havelock: Our Proud Heritage*, at least four residents of Havelock were members of a Klan chapter.[12] Months before the Havelock cross burning, a letter was written to Head Kleagle (a Klan officer responsible for recruiting new members) G.E. Davis by a merchant in Sussex. The letter stated that members of the Klan were living in Havelock, and the merchant requested that they be allowed to join the larger "Klavern" (the Klan term for a local chapter) in Sussex.[13] Editors in charge of the *Kings County Record* were loyal supporters of the Klan, even going so far as publishing ads promoting the recruitment of local men, articles on meetings, and reports of Klan events. As B.J. Grant notes in *When Rum was King*, "nothing was too small for the Klan,"[14] which even got in an uproar over the Red Ensign being flown outside of schoolhouses instead of the Union Jack. If this was true, what would they do if they knew about two men having sex? There is a long history of violence by Klan members against queer people, as the Klan feared that these so-called inverts perverted children and destroyed families.[15]

Even though Len was ousted by his community and subjected to public humiliation and possibly violence, his outing never resulted in a court case. This was most likely because he was able to escape to the United States before he could be charged

with any criminal conduct. It is also possible that the villagers didn't want a scandal. Simply threatening or exposing him and pressuring him to leave town could have been adequate justice in their minds.

Court cases contemporary to the time offer a glimpse of the legal consequences Len could have faced. These cases often provide the only solid points of reference for gay history. (These legal repercussions did not exist for women until 1953, when same-sex relations between women were included under gross indecency laws.) Court cases arose where either party was caught in the act by witnesses or if an assault occurred when the advances of one were not accepted by the other. This criminalization would often lead individuals to deny consenting to the acts in order to escape punishment.

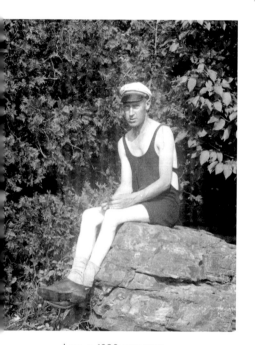

Len, c. 1930. (P27-1022)

The transcripts of these trials can be difficult to interpret. The realities of what happened are often hidden by the language and framing of the cases. Only by reading between the lines can some details be surmised. In June 1934, for example, we read that a Newfoundland sailor, Bernard Butler, committed an act of gross indecency on another male, Theodore Cormier, while the two men were staying at a relief camp in Fredericton. A few days before the act took place, Butler had kissed Cormier and lightly bitten his cheek. Cormier had not rebuked the advance, so perhaps Butler thought he would be welcomed when, a night or two later, he crawled into Cormier's bunk and performed oral sex on him. Cormier prevented any further advances from Butler, at which point Butler began making advances towards one of Cormier's friends, who successfully stopped him. It is possible that this was a consensual act between the two men, but perhaps it was witnessed by Cormier's friend, obligating Cormier to go to the police out of fear of being labeled as complicit. Butler was sentenced to the Dorchester Penitentiary for two years.

To write Len off as one of the lucky ones because he wasn't arrested would be an understatement. However, even though he was able to escape to the United States, his life was completely overturned. He was no longer able to work in his garage, his

fox farming business was ruined (although it appears that Lucy and Agnes were able to keep the operation going into the late 1930s), and most importantly, his connections with his family, friends, and neighbours were broken. He could not return to the places he loved, go for drives along the Kings County roads, visit his hunting camps, swim in the Canaan, or explore the New Brunswick woodlands. If Len had been a devil in his own hometown, now he was something much worse, an outcast without a home.

Cub and Len, c. 1926. (P27-MS1F1-49)

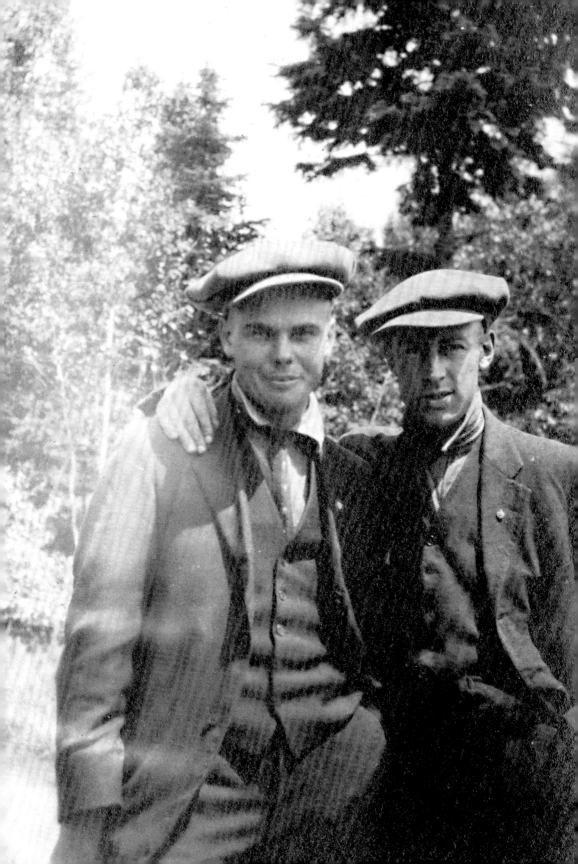

Life Afterwards

The paradox of Len and Cub's lives is that even though there is considerable documentation of their relationship in candid and posed photographs, there are still many unanswered questions. By virtue of his family's status, there is a wealth of information on Len's formative years and early life, but very little is known of Cub's early years before he became involved with Len. But after Len flees to Vermont in 1931, few traces of his later life remain until his death, while there are numerous records pertaining to Cub's adult years.

The last photos of Cub in the Corey collection date from the late 1920s, suggesting that the two men slowly drifted apart after his return from Portland. Cub would have been hard at work on his father's farm and had also been able to acquire a farm of his own through the Soldier's Settlement Board. It was around this time that Cub became a butcher, operating a slaughterhouse on the Upper Ridge Road in Havelock.[1] The business was successful, and Cub ran it for eleven more years in addition to also involving himself (without incident) in the fox farming business. However, he gave this all up when he enlisted in the Second World War.[2]

After war was declared in September 1939, Cub, now 41 and a veteran of the First World War, decided to take up the fight again, joining six months later in February 1940. He

volunteered as a Military Policeman in the Provost Corps, which was responsible for control and discipline of armed forces members, handling enemy prisoners of war, and traffic control of convoys under fire when in action. As a veteran, Cub would have been extremely valuable due to his previous wartime experience and militia training.

Similar to the recruitment process during the First World War, there was no screening or identification process for homosexual soldiers during the Second World War. The court martial records provide examples of the ways in which those found committing indecent acts on other men were punished and shunned by others in their regiments. However, by the time the Second World War began, the army wished to create a strong force of dominant men who were not just physically but also mentally fit, and it established the Directorate of Personnel Selection to oversee this. In 1942, the Royal Canadian Army Medical Corps came up with a classification system called PULHEMS (physique, upper body, lower bodily functions, hearing, eyesight, mental capacity, and emotional stability) to help identify psychiatric disorders, among other issues, and this system labelled homosexuals as psychopathic individuals in need of treatment.[3] The trouble was that there was no consensus on the part of the physicians carrying out the physical and mental examinations on how to identify a homosexual.

As Paul Jackson writes in *One of the Boys: Homosexuality in the Military during World War II*, there was a great difference between the medical categorization of the "homosexual" and the queer men who were in the units.[4] Jackson notes that officers were keen to protect their unit's morale, so if a soldier was found having an illicit affair with another comrade, they often turned a blind eye, ignoring anti-homosexual directives from the military authorities.[5] Among the rank and file of soldiers, "the queerness of good men was commonly overlooked rather than accepted by the other men."[6]

As a member of the Canadian Provost Corps, Cub's main duties involved guarding the detention barracks, and he was based in the United Kingdom for the entire duration of his service. After his training in Ottawa, Cub was sent to Glasgow, Scotland, in early August 1940 and promoted to the rank of Lance Corporal towards the end of that year.[7]

There is a certain degree of irony in looking at the role of the Provost Corps because certain members were assigned to investigate soldiers suspected of homosexual encounters. By the time Cub was invalided out of service due to ill health in 1944, investigations of alleged homosexual soldiers by the Provost Corps were

at their most fervent. Their tactics included identifying queer servicemen through censored correspondence, interrogation of sexual partners, and even camouflaged entrapment, where a member of the military police would go undercover as a queer civilian and lure soldiers on leave into sexual encounters. Once an advance was made towards the undercover provost, the soldier would be arrested.[8] He would face disciplinary action from the military authorities and could be discharged on the grounds of being mentally unfit. There is no evidence in his file that Cub took part in such investigations. However, he may well have been responsible for guarding men arrested for gross indecency.

Although Cub's war record does not reveal the day-to-day nature of his work, it is rather telling of his personality. On one occasion, he was severely reprimanded for unspecified conduct unbecoming a soldier, yet several months later, he was awarded a good conduct medal. Military historian Lee Windsor notes this was not uncommon during this phase of the war, as inaction often seeded tension among soldiers and military police alike.[9] Near the end of his service, Cub received the Canadian Volunteer Service Medal and Clasp for his completion of eighteen months of service.

After his service, at age 45, Cub was not the young man he once had been. His medical records show that he was hospitalized in the Astley Ainslie Institution in Edinburgh twice. He experienced optical headaches and dizziness when performing physical labour along with swelling in his legs. He returned to Canada and was hospitalized at the Sussex Military Hospital for several months, suffering from bronchitis, until he was discharged in June 1944. In Cub's pre-discharge interview, the interviewer wrote that "Coates is a big man of excellent appearance, and education above average. He is very personable, pleasant, co-operative, mellow with sound good judgement. He is of the type that requires no supervision—reliable and trust worthy [sic]—above all else."[10] The interviewer suggested that Cub would make an excellent sales agent for a liquor store. Little did he know that Cub's youth would have also made him immensely qualified.

Strangely, Cub's military records make no mention of his experience as a mechanic in Len's garage, despite the 1921 census listing him as working there. Perhaps leaving this off the record was a conscious decision, with Cub keen to avoid being associated with Len.

. . .

Cub had married Rita Cameron shortly before he left home to fight in the Second World War; although how he met his wife is unknown. Rita Janet Cameron was born in 1901 in Chatham, New Brunswick, spent part of her youth living with her aunt in Port Elgin, and became a nurse at the Moncton Hospital in 1921. Before her marriage she was listed as living on Botsford Street in downtown Moncton.[11] Cub's sisters were living in Moncton at that time, so his sisters may have been friends of Rita's and introduced the two.

Before leaving for training in Ottawa, Cub married Rita in a small service at her Moncton residence. It does not appear that the two knew each other very well at the time of their marriage. There are no society notes of Rita having travelled to Havelock nor of Cub and Rita moving in the same circles before their marriage. However, Rita seems to have been well liked by her friends and would have had a nineteen-year career as a nurse before marrying Cub at the age of 38. Including the four years Cub spent overseas, they were together for 22 years until her death in 1962. They did not have any children.

After the war, Cub returned to Rita in Moncton, and the couple settled down on Church Street in downtown Moncton. He became a contractor and picked up odd jobs where he could. All went well until the late 1940s and early 1950s when he wound up in court on three separate occasions. Cub was by all accounts a kind individual, and it appears that his kindness was taken advantage of by those who hired him for contract work. In any case, the business partners he was working with alleged that he didn't hold up his side of their deals. In one verbal agreement, Cub was tasked with supplying a mill in Albert County with one million feet of lumber. Trying to do the decent thing, he asked to be released from the contract, which the mill owner refused. He was cleared of all three charges, demonstrating that he was the victim of others' enterprising motives.

Cub's decision to move to Fredericton in 1953 and start a new chapter in his life might have been influenced by the business dealings that had resulted in these legal entanglements. By starting over in Fredericton, he could rebuild his professional reputation. He and Rita made the move to 777 Union Street on Fredericton's north side, where he found work at first as a garbage collector.

Cub always had a love for horses and horse riding. Back in the 1920s and 1930s, he and the local Havelock boys had started a track, and his involvement with the harness racing community continued in his later life both in Moncton and

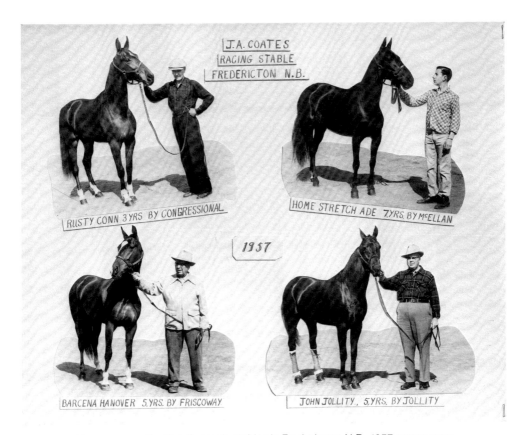

J.A. COATES
RACING STABLE
FREDERICTON N.B.

RUSTY CONN 3 YRS BY CONGRESSIONAL

HOME STRETCH ADE 7 YRS BY M^cELLAN

1957

BARCENA HANOVER 5 YRS BY FRISCOWAY

JOHN JOLLITY, 5 YRS BY JOLLITY

Horses owned by Cub Coates's stables in Fredericton, N.B., 1957. (P342-3151-12)

Fredericton. In the late 1950s, he even owned racing stables near the Fredericton Exhibition Raceway. As his obituary states, Cub was "well known in Maritime harness racing circles" and raised a number of award-winning horses in those years.[12] He frequently went to the tracks, where he would drink beer and get quite excited during the races, which was uncommon, as most racehorse owners preferred a stoic response to the excitement of the races.[13] A success of particular note occurred about a month before his death when his horse, Donna Way, won the prize for top Maritime-bred pacing mare.[14]

After Rita's death in 1962, Cub moved back to Moncton and lived with his sister Winnifred in the Lewisville area. He was not in great shape by then, and Winnifred looked after him in his final years. Cub died on October 12, 1965, at the Moncton Hospital from heart complications.

. . .

Len's trail goes cold until the death of his mother, Agnes, in 1948 when her obituary reveals that he was living in the Montreal area. Len spent his final years in the working class neighbourhood of Mackayville, part of the subdivision of Saint Hubert in the town of Longueuil.[15] Shortly before his death, Len was hospitalized at the Royal Victoria Hospital in Montreal and died from liver cancer on September 21, 1950.[16] It's clear that Lucy cared about and respected her older brother, as she saw to it that his body was brought home and buried in the family plot. A quiet interment took place on September 27, but no mention of Len's death was published in the New Brunswick papers. Small towns have long memories, so it is to be expected that Lucy did her best to keep Len's funeral a discreet occasion. Len and Lucy's relationship endured even after Len's banishment. It seems that, if nothing else, Len had his sister's loyalty.

Agnes Florence (Price) Keith with daughter Lucy Keith, c. 1945. (P27-885)

Whether Len had any partners after the mystery man from the late 1920s who features so prominently in his later albums is unknown. Len seemed able to find the company of men wherever he went however, so it is possible that he led a modest but happy life after being driven from Havelock.

Len had developed a habit of sending photos home to his family. He had done so during his time at Tilton as well as during his training in 1918 in Quebec, and there is a photo in the collection with similar handwriting that dates to the 1930s or 1940s. It depicts a man outside a small rustic house surrounded by apple trees. The back reads: "This is Jim, the thing I have out here with me. He is better looking than this." The language makes it clear that this photo was part of a card or letter sent back to Havelock, but the message is cryptic. The reference to the unknown man as "the thing I have out here with me" suggests a relationship of some sort.

Whether Len and Cub remained in touch is unknown. However, one event that did bring Cub back into the world of the Keith Family was Agnes's funeral, where he was a pallbearer.[17] He lived in Moncton at that time and travelled to Havelock to attend — still clearly a respected friend of the family. It is unclear whether Len, living in Montreal by then, also made the journey home.

Like so many tales of same-sex relationships throughout history, the story of Len and Cub does not have a happy ending. While Cub was able to carry on living a relatively peaceful life in New Brunswick as a respected veteran, husband, and community member, Len was forced to leave the life and the people he knew and loved. Even in death, his sister may have tried to prevent gossip and rumours swirling around Len's past from resurfacing, as there is no mention of his death or burial in the Kings County or Moncton papers.

The photos, however, remain. They testify to the deep affection Len and Cub had for each other. Many of them carefully and artistically composed, they serve as a reminder to us all that love, however fleeting and hidden from the outside world, is finite. Telling the story of Len and Cub is important not just for the sake of queer New Brunswickers but for anyone looking to expand their understanding of this province's history and its changing attitudes towards human rights, gender, sex, and sexuality.

Preserving Len & Cub

Searching the past for traces of queer people in rural environments poses a number of hurdles for historians. Lives are elusive, subject to conjecture, and rarely well documented. This is what makes Len and Cub's story so key. They are an example of a same-sex relationship, but one that must be contextualized by the time and place in which they lived.

Canadian queer historian Valerie J. Korinek's *Prairie Fairies* documents the experiences of 2SLGBTQ+ people in the Canadian Prairies, stating that "[s]earching for Queer people then, and historically, was not an easy process, even if we know logically that 'queer people are everywhere.'"[1] The nature of queer relationships and how the people in them might have described them, along with their own understanding of their same-sex attractions, cannot be interpreted clearly through a contemporary lens. As Korinek notes, historians must tread lightly when ascribing labels and terms to people of the past.

The story of Len and Cub is a rare example of a long-term Canadian male same-sex relationship from the 1910s to the 1930s, and one which bears certain similarities to those of their Canadian female queer contemporaries, Bud Williams and Frieda Fraser. As Cameron Duder writes in *Awfully Devoted Women: Lesbian Lives in Canada, 1900-1965,*

"The boys" on an outing in the late 1920s.
(P27-MS1F1-51, P27-MS1F1-50)

historians have concentrated on middle-class, non-sexual "romantic friendships" and working-class "butch-femme" relationships while often excluding other forms of relationships, such as femme-femme couples and bisexual women.[2] The records that document the relationship between Frieda Fraser and Edith (Bud) Bickerton Williams are just as rare as the photos of Len and Cub, but in their case the traces that have been left are in the form of a collection of letters held at the University of Toronto that cover the whole span of their long relationship from 1918 to 1979, when Bud died.[3] The two were eventually able to live together and have successful careers, Frieda becoming a professor in the Department of Hygiene and Preventive Medicine at the University of Toronto and Bud becoming the second female veterinarian in Canada. While their shared love of the outdoors and the time in which they lived are comparable to Len and Cub's relationship, Frieda and Bud's gender, wealth, social status, careers, and urban locale worked to their advantage to socially camouflage their relationship as simply two working women who lived together.

Len and Cub certainly did not enjoy the same advantages, which could have facilitated them living together, nor could their relationship escape the speculation and homophobia that would eventually drive Len out of Havelock. Evidence of male same-sex relationships from this period is often limited to court records and

newspaper reports for those charged with gross indecency. The case files are opaque with legal jargon and often do not give a full account of what truly happened. Newspaper reports of these cases were influenced by the journalist's biases, and many other records testifying to queer relationships, such as letters and diaries, were destroyed either by the writers or their family members, close friends, or even archivists. This destruction was based on fear, disgust, or the assumption that the material was inappropriate. With this in mind, Len's photos are all the more important to building our understanding of male same-sex relationships at this time.

Aside from John Corey, who donated these records, the other unsung hero in this tale is Len's sister Lucy. It would have been quite easy for her to have thrown out Len's albums or remove any photos that alluded to his relationship with Cub, especially after Len's death in 1950. Although it is entirely possible that she did destroy more intimate photos of the two, the authors of this book are grateful to her for seeing that the albums we have were preserved until her death in 1984.

Lucy must have cared for her older brother. She never married, and before he left Havelock, Len and Lucy were responsible for the store and spent a great deal of time together. Lucy also saw to it that Len was brought home and buried in the family plot after his death. More queer relationships have surely existed beyond what few records remain, and it is thanks to individuals like Lucy and John that we have any evidence of this rural love story at all. Decades of active suppression of records have created and continue to create a skewed version of history that omits the lived realities of queer New Brunswickers from bygone eras. The story of Len and Cub is a prime example of queer records hiding in plain sight. Only by reexamining them could their story properly be told.

This same lack of historical sources contributes to our poor understanding of queer lives, be they two-spirit, trans, queer people of colour, immigrant communities, female-identified, or rural. Examples of relationships like Len and Cub's are part of growing historical research and discourse examining the traces of lives from the past through a queer lens. Queer archival initiatives are essential for piecing together the lived experiences of 2SLGBTQ+ people: not just the stories of contemporary activists fighting for civil rights, but of individuals and communities that, consciously or not, challenged the status quo of gender, sex, and sexuality of their time. No longer can we turn a blind eye to these stories and continue to silence the lived realities of queer New Brunswickers.

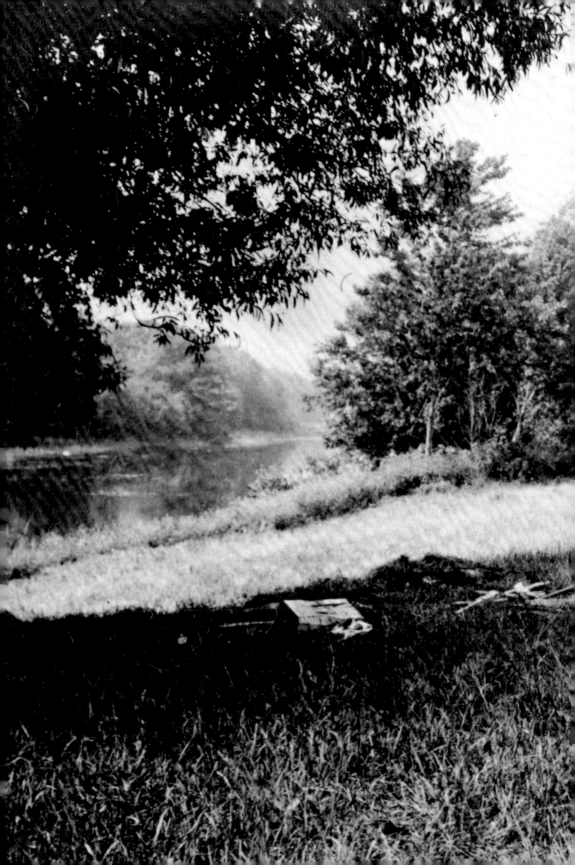

Len and Cub on an excursion to Jemseg, c. 1916. (P27-MS1O1-172)

Afterword

MEREDITH J. BATT

The story of Len and Cub is heartwarming in many aspects, but it is also an example of where we have come from. It is a tale we all can learn from, especially as we move into an evolving world where there is greater acceptance. Over the course of writing this book, Dusty and I went through our own journeys as to what this book meant, means, and hopefully will mean to us and to its readers. Dusty started looking into the lives of Len and Cub in 2016, and I am grateful to him for allowing me to join this project and help research and write about "our boys."

Working on and researching Len and Cub's story to make it accessible to others has been my raison d'être for embarking on this project. Growing up in southeastern New Brunswick in the late 1990s and early 2000s, I felt an absence of queer people or culture in my childhood, pre-teen, and teen years. As a teenager, I struggled with the lack of queer role models to look up to or identify with. The queer adults in my world were not openly out, and I only found out years later that they identified as part of the 2SLGBTQ+ community. I was indeed privileged to grow up in a loving and accepting home where homophobic language was not tolerated and differences were embraced; however, outside

my family, queer people were usually talked about in a pejorative and ostracizing way, and queer history or sex-ed was definitely not discussed in the classroom.

I have always had a passion for learning about the past. During my undergraduate studies in history at Université de Moncton, I struggled with my newly accepted sexuality and how to express myself openly while learning a second language. I was also unsure of how queer people fit into the past. Fortunately, I had professors who helped foster my interest in queer history and the history of sexuality—Joceline Chabot and Jeremy Hayhoe—and who encouraged me to write this book—Phyllis E. LeBlanc. I credit this time with planting the seeds of my passion for queer history. Eventually all of my interests—sexuality, history, testimony of people's lived experiences, and the manner in which these things are expressed, recorded, and transmitted—would dovetail with my career as an archivist.

As an archivist, the thrill of a historical mystery excites me to no end, especially those that deal with the lives and experiences of people who have been overlooked in the past. Traces of such stories are elusive and often ephemeral in their own nature and in the nature of their material. A great deal of care and research is required to situate the story properly in the context of its time while still making it clear to contemporary readers. Throughout this project, we spent many an hour poring over a variety of documents—including motor vehicle, militia, and school records—as well as making an extensive search in the *Kings County Record* newspaper as we looked for contextual information on Len and Cub's lives and those of their family members and friends. Our search even took us to Quebec and outside Canada to Maine and Vermont, all in service of finding any clues to Len's whereabouts from 1931 to 1948. I feel that we have given our hearts and souls to this project in researching "our boys."

We have worked hard to chase even the smallest detail in the hopes of being as accurate as possible. We met frequently to discuss the elements, situations, and possible scenarios of Len and Cub's lives based on the evidence gleaned from the photos and historical records. We have had to make many difficult decisions on what to include and which images we thought best explained the story. We have worked hard to be honest with the reader when we do not know what exactly happened and to propose our theories of what we think may have occurred. We hope you are pleased and moved by this story, and that you understand how we came to dedicate so much of ourselves to these two individuals we never had the opportunity to meet.

In writing this book we have been fortunate to have had many experiences, including travelling to Havelock to see the village that the boys loved, staying at the archives way too late into the evening, and meeting and talking with different people about our project. Unfortunately, during the writing of this book we lost our friend and mentor R.M. (Richard Murray) Vaughan (1965-2020), queer writer, poet, and artist, to whom this book is dedicated. We are profoundly grateful to Richard for our many discussions, his encouragement of our work, and his generosity of spirit. He was a one-of-a-kind person, and he is a treasure that I hope one day New Brunswickers will fully appreciate.

Finally, I feel that it is important to note that Len and Cub's story is just the tip of the iceberg in terms of telling the queer histories of this province. I hope to dedicate my career as an archivist to help bring queer archival material into the classroom and to the public so that we can all learn from the examples of resilience from previous generations of queer people. My work at the Provincial Archives and with the Queer Heritage Initiative of New Brunswick has taught me that there is a rich history of diverse experiences of groups, activists, and individuals waiting to be told. There is still much work to be done in collecting and preserving these stories for future generations. They have been overlooked and suppressed for far too long. The time has come to tell them.

Appendix I

A BRIEF QUEER HISTORY OF NEW BRUNSWICK

Len and Cub are not the first example of a queer story from New Brunswick, but they are an extremely rare example of one that can be explored at length, thanks to Len's personal photographic records. Legal cases from the past are devoid of emotion and detail and are often skewed by prosecutors or by the legal and societal understanding of queer experiences at the time. There are few reliable records of queer life in New Brunswick before the middle of the twentieth century, but the number of records explodes after 1969, a year known the world over as a landmark step forward for queer liberation.

The year 1969 was undeniably a turning point for queer people in North America, but its legacy in the annals of queer history does contain a certain level of mythologizing that glosses over the reality of queer people who lived through the era. Yes, queer liberation occurred, but liberation was met with extreme resistance, a push and pull that would persist for decades, as public institutions (law, education, public services, and so on) resisted the demands of queer people seeking human rights legislation and the freedom to live and love openly.

As historian Tom Hooper notes, before 1969 there was no law specifically against homosexuality as such. Same-sex sexual acts were criminalized as gross indecency, buggery, and indecent assault, and many men continued to be arrested under these laws well after 1969.[1] The exception added to section 149 of the Criminal Code in 1969 removed criminality for gross indecency and buggery for married heterosexual couples if the act was done in private and involved no more than two consenting adults over the age of 21. If the act took place in a public area or if there was another person involved or present, it was a criminal offence.[2] Society's views, upheld by police and the judicial system, still saw homosexuals as degenerate and intrinsically criminal.[3] In most cases, families of homosexuals were not supportive, and few young gay men of all ethnicities could afford their own "private" space in which to conduct their affairs. With no space to find sex or companionship at home, many men relied on late-night cruising in public parks, bathrooms, and bars. The 1969 amendment did nothing to protect them. May 2019 marked fifty years since the Criminal Code was amended and sparked great public confusion when the Canadian government encouraged a false historical narrative that suggested the amendment had "decriminalized homosexuality," even commemorating the event with a coin from the Canadian Mint.[4]

So what was life in New Brunswick like before and after the 1969 amendments? Criminal cases in New Brunswick prior to 1969 confirm that men were being arrested for public sex. In 1950, two Moncton men were found together in a hotel room and arrested after the proprietors alerted the police. Both men were charged with buggery.[5] In 1961, two men in Woodstock were arrested and faced prison time for nearly being caught in the act while in a car. The judge acquitted them on insufficient evidence and the claim that they were too drunk to remember.[6] Arguing intoxication as a factor was often used as a way to plead not guilty or to have a sentence reduced, the implication being that men's drunken "fooling around" should not be taken too seriously. A case from 1962 in Carleton County, however, demonstrates the damage that was done to those who were arrested and forcibly outed to their families, when a labourer was separated from his young family after being charged with gross indecency.[7] Even though changes were made to the criminal code in 1969, they did not guarantee that arrests would no longer be made. In 1973, for example, an arrest was made in Saint-André, Madawaska County. While details on exactly where the offence took place are vague, the accused was sentenced to three years imprisonment for performing fellatio on another male, presumably in a public place, thereby violating the criminal code.[8]

The laws on gross indecency did not take into consideration women's sexual desires until 1953, when gross indecency laws were extended to women who pursued same-sex experiences. Our knowledge of female same-sex experiences is often limited due to their being dismissed as romantic friendships. In *Any Other Way: How Toronto got Queer*, Kate Zieman writes about a female couple whose photos were donated in the early 2000s to the ArQuives. The photo collection belonged to Thelma (Ted) Clarke, who was from the Mactaquac area outside of Fredericton.[9] Ted was a member of the Canadian Women's Army Corps in the Second World War and afterwards settled in Toronto, where she met her life-partner Queenie French (originally from Kapuskasing, Ontario) in the early 1950s. Like Len, Ted loved cars, and the photo albums at the ArQuives contain pictures of various trips home to the East Coast where the two visited Ted's family on numerous occasions and explored New Brunswick together.

Not only did the 1969 reforms do little to mitigate the number of men being arrested for consensual sex, they also failed to provide homosexuals with full human rights. The struggle for these would continue for years to come. After the Stonewall Riots in New York in June 1969, gay-liberation organizations sprang up across North America, and the Maritimes were no exception. New Brunswick's first gay-liberation group was known as Gay Friends of Fredericton (GFF) and was formed in 1974 by Keith Sly. GFF was eventually taken over by Harold "Hal" Hinds, a botany professor at the University of New Brunswick, who was also integral to the formation of a number of other LGB and ecological organizations, including AIDS New Brunswick and the New Brunswick Coalition for Human Rights Reform. Along with Allison Brewer, Hal and a few friends formed Fredericton Lesbians and Gays, or FLAG as it was affectionately known, in 1979. The group was most active between 1979 and 1985, and it was during this time that more queer public spaces began developing, as the 1970s were still largely a time of underground socializing.[10] As Conor Falvey writes in *Foregrounds: Mapping Gay, Lesbian & Bisexual History in Fredericton, 1969-1992*, Hinds was adamant that FLAG was not just a dating service. The goal was to help change societal attitudes and work towards legislative protections for LGB New Brunswickers.[11]

In the years that followed, FLAG organized dances at various locations across the city, including UNB's Student Union Building and the Kinsman Centre on the North Side, which were well attended and acted as the organization's primary source of income.[12] Before these dances, queer socialization had been limited to private parties, cruising areas, and chance encounters. Now, with an organization

to gather around and a regular schedule of social events, queer New Brunswickers were able to plan and mobilize to spend time together. During their peak, FLAG's dances drew in more than a hundred attendees, with many of them travelling from rural parts of the province and beyond, including Maine and Nova Scotia. The organization also partnered with other early gay liberation groups such as Les Gaies et Lesbiennes de Moncton / Gays and Lesbians of Moncton, the Lesbian and Gay Organization (LAGO) of Saint John, and Northern Lambda Nord in Caribou, Maine, to address the social needs of queer people living in rural areas. Their events included outdoor activities such as picnics, beach parties, and camping trips. Organizing social gatherings was time-consuming work, which meant that FLAG's initial goal of establishing legislative protections for LGB New Brunswickers had a relatively slow start. Still, these early events are an important milestone for queer community-building in the province.[13]

Of all the queer scenes in New Brunswick, Moncton was known as the "province's social hub."[14] Les Gaies et Lesbiennes de Moncton / Gays and Lesbians of Moncton formed in 1982 after an incident in July of the previous year when Moncton's gays and lesbians had planned to congregate at Centennial Park on Canada Day for a meet and greet and to have a simple picnic.[15] Coverage by the *Moncton Transcript* caused quite a stir and opened the door to local political backlash when the newspaper reported an inflated figure for the number potentially attending the event.[16] Moncton's City Council rushed, days before Canada Day, to pass a by-law that groups of over fifty people would have to apply for a permit to hold an event. As a result, picnickers attended as individuals and not as a group so as to undermine the new rule, and a lesbian and gay boycott of the city's businesses was urged by the event organizers.[17] The fact that city hall could move so quickly to deter a simple picnic because of the attendees' sexual orientation is certainly an indication that human rights legislation was desperately needed.

Falvey explains that the opening of the province's first queer bar, Dance Trax, in Fredericton in 1985 was a historic culmination of all the work done by the activists of GFF and FLAG over the past decade.[18] However, when Dance Trax opened, it took away FLAG's primary source of revenue, the dances. By the late 1980s, FLAG's membership had splintered into several groups, including the New Brunswick Coalition for Human Rights Reform and AIDS New Brunswick. With the success of Dance Trax, however, FLAG's activist members found more time and energy to work on human rights reform and securing employment and housing protections for LGB New Brunswickers.[19] From 1988 until their success in 1992, the Coalition

worked diligently to lobby the provincial government to add sexual orientation to the Human Rights Code. It is important to remember that, because queer people were not protected under provincial human rights legislation, they were often subject to employment termination and were not welcome in many restaurants or bars: they could be asked to leave if the owner felt uncomfortable. Gay bashings, where people who are perceived as being queer are harassed or assaulted by other individuals, were a real danger for people cruising on the Fredericton Green late at night. Even if these attacks were reported, the police were not likely to take the complaints seriously and little was done to help the victims.[20]

The queer scenes that we have in New Brunswick today did not emerge overnight. They are the product of hard work by queer activists and allies from across the province over many decades. New organizations, such as Moncton River of Pride / Rivière de la fierté, founded in 1999, have picked up where old ones have left off. After the successes of FLAG in the 1970s and 1980s and the vital work of the Coalition for Human Rights Reform in the 1990s, it is almost inconceivable that Fredericton's first official pride parade took place only in 2010. The parade of 2009 had to be held on the riverfront walking trail, as the Fredericton City Council refused to sanction the event.

As we enter a new decade, the situation for queer people in this province is still far from perfect. Access to transgender healthcare services remains extremely limited, and the closure of Clinic 554 in Fredericton in September 2020 leaves trans clients in a precarious position. Clinic 554 not only offered access to surgical abortions (one of only four facilities in the province where this procedure can be performed, two of which are in Moncton), but it was also a safe and supportive environment for 2SLGBTQ+ patients who had switched to the clinic after experiencing outdated homophobic and transphobic attitudes from their family practitioners.[21]

The rural / urban divide in our province makes it difficult for organizations to make educational inroads in rural communities. Rural queer and trans youth are still at the mercy of homophobic and transphobic attitudes and often face stigma and abuse based on strict religious or ill-informed views held by their family or support networks. Conversion therapy is still practiced by various church groups to "cure" New Brunswick's youth of homosexuality, and teenagers are coerced into these sessions under the belief that they are in need of "reparative therapy" (the long-awaited ban on conversion therapy that came into force on January 7, 2022, is a much-needed boost in this area).[22] Many queer New Brunswickers still feel unsafe

in certain parts of the province and struggle to see themselves represented in the many structural institutions of our society.

Despite our marginalized past, the records that remain show that queer New Brunswickers existed and displayed incredible resilience in the face of intense queerphobia and institutional oppression. This is part of the reason why Len and Cub's story is so relevant in today's world. In a province where queer youth face higher suicide rates than their straight peers and human rights issues around queer and trans lives are constantly up for debate, it is more important now than ever that 2SLGBTQ+ New Brunswickers know that they have always been a part of this province, fighting through adversity and finding happiness and love in times of significant hardship. Understanding the history of the struggles and resilience of queer people from our past gives us the tools for moving forward together in the future, creating stronger allyship, and supporting each other.

Appendix II

QUEER ARCHIVAL WORK
IN NEW BRUNSWICK

Given that archival institutions have not always collected records related to queer people and in some cases have actively worked to suppress queer content in their collections, it should come as no surprise that queer scholarship and queer-inclusive education in New Brunswick is lacking. Societal attitudes at the time prevented these records from being collected, meaning that researchers, academics, historians, and educators did not have the building blocks at their disposal to tell queer stories and create an integrated history of queer people. By suppressing marginalized stories, entire groups of people are effectively written out of history, further othering them from the dominant culture.

This erasure has contributed to a myriad of social ills impacting queer New Brunswickers to this day, as it continues to permeate many institutions in the province, including in education and historiography, healthcare, and youth and elder services. While understanding and support for queer youth is much better than it was in the past, the lack of a queer-inclusive curriculum in social studies, sex education, and history places queer identities in a peripheral position within our education system and, by proxy,

marginalizes queer youths themselves. There must be a greater effort on the part of educators to integrate content relating to queer (and other marginalized communities) into the curriculum and school life at large, not just for the benefit of queer youth but for all students, creating an environment that normalizes gender and sexual diversity without othering queer students and subjects.

The Queer Heritage Initiative of New Brunswick's small collection of 2SLGBTQ+ material has been growing rapidly since it was founded in 2016. It is housed within our partnering institution, the Provincial Archives of New Brunswick in Fredericton, and contains a variety of materials from the time of the formation of early gay liberation organizations in the 1970s to the present day and includes oral histories, Pride Week records, and various ephemera. As part of QHINB's mandate, we organize and collaborate on public education opportunities in order to strengthen the public's understanding of queer history and lived experience in the province. We also use our holdings to foster community building through intergenerational discussion panels where youth have the opportunity to learn from queer elders and vice versa.

Community Archives like QHINB and the national queer ArQuives in Toronto are actively working to include the stories of marginalized populations, specifically stories from Black and Indigenous / People of Colour (BIPOC) communities, and encourages these communities to take control of their own history, which has previously been suppressed, ignored, or disregarded. Often, queer BIPOC activists are reluctant to donate their material, or their stories have not been sought out by queer archival organizations, leading younger generations and researchers to the dangerous perception that BIPOC individuals were not involved in LGBT liberation movements. This viewpoint is especially prevalent in the smaller, more rural provinces of Atlantic Canada, when in fact BIPOC individuals contributed greatly to these organizations and not only experienced discrimination based on their sexuality but also racism both inside and outside the queer community.[1] Along with the need to include and capture marginalized voices, there is also a sense of urgency that motivates the collection of queer archival materials throughout Atlantic Canada before they are lost to time as generations of queer people pass away. There remains much work to be done in this field, and with this in mind, the work of QHINB has just begun.

Queer Heritage Initiative of New Brunswick

Initiative du patrimoine Queer du Nouveau-Brunswick

Acknowledgements

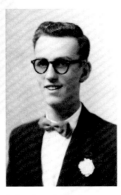

John Jacob Corey,
c. 1950s.

In writing this book, we are greatly indebted to John Jacob Corey, who was born in Havelock in 1933. He valued his community, his province, and its art. John's father, Roy Corey, was a school chum of Len's and he would have known Len and Cub well, growing up as they did in the small community of Havelock.

In 1984, after the death of Len's sister Lucy, her estate was put up for auction. The auction took place over several days, and John Corey attended that auction and purchased a sizable collection of Keith family photos that were part of the goods on offer. John then donated the photographs to the Provincial Archives of New Brunswick in 2011. He described the two men in the photographs as "boyfriends" to archivist Julia Thompson and further noted that Len had been forced to leave town because he was a homosexual. Without this donation—and his help confirming and documenting the relationship between these two men—Len and Cub's story would have been lost forever. In short, without John Corey, this book would not have been possible.

During a research trip to Havelock in November 2019, we were fortunate to meet with Bob Osborne, Lee Saunders, and Ruell Sloan at Lee's family farm in Intervale to talk about John Corey's life, work, and character and to discuss their family memories of

Havelock during Len and Cub's time. Thank you, too, to Peter Larocque, Head Curator at the New Brunswick Museum, for sharing his memories of John.

Ava Dickson's grandfather, Allan Jones, remembered Cub vividly during the 1950s and provided information about Cub's character as an older man. We are also grateful to Kate Baglole, whose grandparents shared their memories of Len and Cub's story with her.

We are indebted to many people who helped us over the course of this project and took an interest in Len and Cub's story: We owe a special thanks to John Leroux, manager of Collections and Exhibitions at the Beaverbrook Art Gallery; the team at Goose Lane Editions, particularly Alan Sheppard, Julie Scriver, and Susanne Alexander, for recognizing that Len and Cub's story needs to be told; and our editors, Simon Thibault and John McAllister, for helping us deliver this story in its best form.

The Provincial Archives of New Brunswick were a vital resource in our research. We are immensely grateful to the dedicated PANB staff who provided invaluable mentorship and expertise: Mary-Ellen Badeau, Roger Drumond, Fred Farrell, Robbie Gilmore, Joshua Green, Heather Lyons, and Julia Thompson. We would particularly like to thank Joanna Aiton Kerr for her support and mentorship as a friend and colleague and her husband James Kerr for his help sourcing books and materials so we could continue our research during the pandemic.

Jules Keenan digitized the images for reproduction and artfully colourized the photo of Len and Cub picnicking.

Thank you to Christine Jack and Leah Grandy at UNB's Harriet Irving Library for their assistance with locating copies of the *Kings County Record* and to Caroline Jonah, Koral LaVorgna, Chase Plourde, and Monica Smart for helping us comb through the many, many microfilm records.

The administrative staff at Tilton School in New Hampshire helped locate Len's college records, and Tiffany Link of the Maine Historical Society researched Len's time in Portland, Maine. Our own research into Len and Cub's military records and our understanding of military culture in the First World War were supported by the staff at Library and Archives Canada, as well as Tim Cook at the Canadian War Museum, Kevin Robins and Hal Thompson at the Halifax Citadel, Cindy Brown and Lee Windsor at the Gregg Centre for the Study of War and Society, and Nicholas Green.

We would like to acknowledge the encouragement of current and former staff and volunteers of the ArQuives in Toronto: Raegan Swanson, Rebecka Sheffield, Jade Pichette, Ed Jackson, and Alan Miller. Thank you, also, to the QHINB board, to Ken Setterington for early encouragement, and to Sarah-Jonathan Parker.

We appreciate the financial support of a Documentation Grant from artsnb.

We are deeply grateful to the queer elders who affirmed the importance of this story. We have been truly inspired and motivated by their own stories of resilience.

Finally, we would like to thank family and friends who supported us during this project:

My wonderful parents, Ronald Batt and Leslie Chandler, and my brother, Adrian, who have always accepted me, encouraged my work and activism, and helped keep me going through rough patches. My Nanny B (knitter of the coziest pride blanket to keep me warm while writing). To Monica Smart for her friendship and patience and for providing adventures when I needed a break. Donald and Joanne Wright who have provided not only a place to live, but much encouragement and editing assistance. Sarah Glassford, Jen Hall, and Hilary LeBlanc — I enjoy our chats tremendously and you inspire me! To France Duguay and Juliette Bulmer, who played such a pivotal role in my university days and continue to encourage my work in the queer community. To Amelia Thorpe and Linsay Nickum, who do so much for the queer community in Fredericton and across the province. **— MJB**

To my family, and my partner Stephane Cormier, for their unwavering support, and to Amanda Ellis and Koral LaVorgna for their friendship and helping at every step of the project. To Thom Vernon, who provided a safe space for Meredith and me after the passing of our friend R.M. Vaughan. **— DG**

Notes

Preface

1. Parks Canada, "Internment Operations at the Halifax Citadel during the First World War," June 26, 2014, https://web.archive.org /web/20150510064949/http://www.pc.gc.ca /lhn-nhs/ns/halifax/natcul/natcul13.aspx

2. Lilly Koltun, *Private Realms of Light: Amateur Photography in Canada 1839-1940* (Toronto: Fitzhenry & Whiteside, 1984), 16-19.

Finding Len & Cub

1. Nils Hammarén and Thomas Johansson, "Homosociality: In Between Power and Intimacy," *SAGE Open* 4, no.1 (January 2014), doi:10.1177/2158244013518057: "Homosociality describes and defines social bonds between persons of the same sex." Homosocial spaces are places where these bonds are developed and reinforced. Len's garage and pool hall, for example, was a homosocial space.

Languages of Desire

1. While the English term Two-Spirit dates from the 1990s, it is a fluid term and an individual experience that is used to describe the cultural, gender, and sexual identity of Indigenous people. We have chosen to list it first to acknowledge that Two-Spirit sexuality predates colonial contact.
2. A federation made up of German states controlled by Prussia from 1866-1870 (now part of modern Germany and Poland).
3. Judit Takács, "The Double Life of Kertbeny," in *Past and Present of Radical Sexual Politics*, ed. G. Hekma (Amsterdam: University of Amsterdam, 2004), 51-62.

4. Julia Nicol, *Legislative Summary: Bill C-32: An Act related to the repeal of section 159 of the criminal code*, Publication no. 42-1-C32-E (January 11, 2017), https://lop.parl.ca/staticfiles /PublicWebsite/Home/ResearchPublications /LegislativeSummaries/PDF/42-1/c32-e.pdf.
5. Petition requesting banishment for John M. Smith, Gabriel George Ludlow fonds (Provincial Archives of New Brunswick, Fredericton, RS331/C/n.d./1-1.1).
6. Lorna Hutchinson, "Buggery Trials in Saint John, 1806: The Case of John M. Smith," *University of New Brunswick Law Journal* 40 (1991): 134.

7. *Secret Life of Canada*—"Crash Course on Dr. James Barry and Victoria's Transgender Archives," CBC Podcast (June 16, 2020), https://www.cbc.ca/listen/cbc-podcasts/203-the-secret-life-of-canada/episode/15782544-s3-crash-course-on-dr.-james-barry-and-victorias-transgender-archives.

8. Michael Horne, *Boarding School Homosexuality: From Plato's Academy to the Princeton Rub* (Bolton: Amazon, 2018), 103.

9. William A. Schabas, *Les infractions d'ordre sexuel* (Cowansville: Les Éditions Yvon Blais, 1995), 88 [translation]; quote pulled from Chloe Forget, "Legislative Summary: Bill C-66: An Act to establish a procedure for expunging certain historically unjust convictions and to make related amendments to other acts" (Publication No. 42-1-C66-E, 28 September 2018), https://lop.parl.ca/staticfiles/PublicWebsite/Home/ResearchPublications/LegislativeSummaries/PDF/42-1/c66-e.pdf.

10. Tom Warner, *Never Going Back: A History of Queer Activism in Canada* (Toronto: University of Toronto Press, 2002), 19.

11. Ron Levy, "Canada's Cold War Purge of LGBTQ from Public Service," in *The Canadian Encyclopedia* (Historica Canada, October 3, 2018), https://www.thecanadianencyclopedia.ca/en/article/lgbtq-purge-in-canada.

12. Christopher Looby, "Flowers of Manhood: Race, Sex and Floriculture from Thomas Wentworth Higginson to Robert Mapplethorpe," *Criticism*, 37, no. 1 (1995): 109-56, www.jstor.org/stable/23116579.

13. William Leap and Tom Boellstorff, eds. *Speaking in Queer Tongues: Globalization and Gay Language* (Chicago: University of Illinois Press, 2004), 98.

14. P. Paul Baker, *Polari: The Lost Language of Gay Men* (London: Routledge, 2002).

15. "gay, a.1-9," *OED Online* (March 2020), https://www.oed.com/oed2/00093147.

16. Michael G. Long, *Gay is Good: The Life and Letters of Gay Rights Pioneer Franklin Kameny* (Syracuse: Syracuse University Press, 2014), 7-8.

17. Warner, *Never Going Back*, 173-86.

18. Warner, *Never Going Back*, 248.

19. Jonathan Alexander, Deborah T. Meem, and Michelle A. Gibson, *Finding Out: An Introduction to LGBTQ Studies* (Los Angeles: Sage, 2018), xxi.

20. Alexander, Meem, and Gibson, *Finding Out*, 2.

Beginnings in Butternut Ridge

1. Havelock Women's Institute, *Butternut Ridge-Havelock: Our Proud Heritage* (Moncton: McCurdy Printing Limited, 1990), 21.

2. Havelock Women's Institute, *Butternut Ridge-Havelock*, ii.

3. Len's middle name has been a subject of debate throughout this project. No baptismal record has been found; the Anglican records of the time for Havelock seem to have parts missing. Len's war record gives his name as "Leonard Olive Keith" consistently, while his notice of death in the *Montreal Star* gives his middle name as "Oliver," presumably a typo, as Len's gravestone clearly states that his middle name was "Olive." Throughout his life, he signed his name as "Leonard O. Keith." However, some mystery remains as to who his namesake was. Most of the Keith children's names paid homage to family members, close friends, and old Havelock families. One clue may be the diaries of Glorana Fownes, a record of her travels with her sea-faring husband Captain W.H. Fownes. Around the time of Len's birth, she travelled with her husband to Glace Bay to bring a shipment of coal back to Saint John. They brought along the employer's sons, Leonard and Walter Olive, aged 14 and 12. The boy's father, Herbert J. Olive, could have been a close friend of the Fownes or Keith families.

4. Havelock Women's Institute, *Butternut Ridge-Havelock*, 30.

5. Havelock Women's Institute, *Butternut Ridge-Havelock*, 38.

6. Provincial Archives of New Brunswick, "Place Names of New Brunswick: Where is Home? New Brunswick Communities Past and Present – Havelock," https://archives.gnb.ca/Exhibits/Communities/Details.aspx?culture=en-CA&community=1701.

7. Havelock Women's Institute, *Butternut Ridge-Havelock*, 31.

8. Ronald Rees, *New Brunswick: An Illustrated History* (Halifax: Nimbus: 2014), 147.

9. Archibald Blue, *Report of the Fourth Census of Canada, 1901: Volume 1, Population* (Ottawa: S.E. Dawson, 1902), 146, https://publications.gc.ca/collections/collection_2016/statcan/CS98-1901-1.pdf.

10. Blue, *Report of the Fourth Census of Canada*, 292. Other minorities enumerated in the 1901 census and included in the totals for the county were: 64 "Aboriginal" people and 26 "Blacks." Blue, *Report of the Fourth Census of Canada*, 18.

11. Havelock Women's Institute, *Butternut Ridge-Havelock*, 28.

12. Todd Gustavson, *Camera: A History of Photography from Daguerreotype to Digital* (New York: Sterling Signature, 2009), 70-71.

13. Motor Vehicle Administration Records, Provincial Archives, Fredericton, RS15/C/3.

14. Motor Vehicle Administration Records, Provincial Archives, Fredericton, RS15/C/4.

15. Ronald Rees, *New Brunswick's Early Roads: The Routes that Shaped the Province* (Halifax: Nimbus Publishing, 2012), 152.

16. King County School Returns, Havelock Superior School, June 1910, Provincial Archives of New Brunswick, Fredericton, F4470.

17. Tilton School Record: Leonard O. Keith, 1914 (Provided to authors by administrative assistant of Tilton School, February 22, 2018).

Len's Camera

1. Gustavson, *Camera*, 129.

2. Koltun, *Private Realms of Light*, 15.

3. Koltun, *Private Realms of Light*, 16.

4. Koltun, *Private Realms of Light*, 32.

5. Koltun, *Private Realms of Light*, 77.

6. Koltun, *Private Realms of Light*, 55.

"The Love That Dare Not Speak Its Name"

1. John Howard, *Men Like That: A Southern Queer History* (Chicago: University of Chicago Press 1999), xvii.

2. George Chauncey, *Gay New York: Gender, Urban Culture, and the Making of the Gay Male World 1890-1940* (New York: Basic Books 1994), 48-57.

3. Chauncey, *Gay New York*, 51-52.

4. Chauncey, *Gay New York*, 56-61.

5. Chauncey, *Gay New York*, 47-63.

6. Layli Phillips, "Deconstructing 'Down Low' Discourse: The Politics of Sexuality, Gender, Race, AIDS, and Anxiety," *Journal of African American Studies* 9, no. 2 (2005): 3-15, http://www.jstor.org/stable/41819081.

7. From the 1940s to 1960s, police in Canada at a local level harassed "deviants," especially men found wearing women's clothing, with whatever law was available. See Craig Jennex and Nisha Eswaran, *Out North: An Archive of Queer Activism and Kinship in Canada* (Vancouver: Figure One Publishing, 2020), 47.

8. Chauncey, *Gay New York*, 99.

9. Chauncey, *Gay New York*, 100.

10. Emily Skidmore, *True Sex: The Lives of Trans Men at the Turn of the 20th Century* (New York: New York University Press, 2017), 6.

11. Chauncey, *Gay New York*, 20-23, 355-8.

12. Leila J. Rupp, *A Desired Past: A Short History of Same-Sex Love in America* (Chicago: University of Chicago Press 2002), 39-41.

13. Colin Spencer, *Homosexuality in History* (San Diego: Harcourt Brace, 1995), 324.

14. Howard, *Men Like That*, 123.

The Pursuit of Affection

1. Tim Retzloff, "Cars and Bars: Assembling Gay Men in Postwar Flint, Michigan," in *Creating A Place For Ourselves: Lesbian, Gay, and Bisexual Community Histories*, ed. Brett Beemyn (New York: Routledge, 1997), 243.

2. Howard, *Men Like That*, 60-62.

3. Havelock Ellis, *Studies in the Psychology of Sex* (New York: Random House, 1942), 89.

4. Howard, *Men Like That*, 171.

5. *Kings County Record*, February 23, 1894.

6. Chauncey, *Gay New York*, 182.

Off to War

1. "Notice of Granting Letters Patent – Havelock Mercantile Co. Limited," *Saint John Standard*, January 4, 1916.

2. "The Local News," *Kings County Record*, September 25, 1914, 10.

3. "Havelock Gives Banquet to Its Soldiers," *Daily Telegraph and Sun*, May 3, 1916, 8.

4. *Moncton Daily Times*, October 18, 1917, 6.

5. "Woman from Havelock held in St. John," *Kings County Record*, October 1, 1915, 3.

6. "Werner Horn's St. Croix bridge bombing in WWI happened 100 years ago today," CBC News – New Brunswick, February 2, 2015, https://www.cbc.ca/news/canada/new-brunswick/werner-horn-s-st-croix-bridge-bombing-in-ww-i-happened-100-years-ago-today-1.2940299.

7. Andrew Theobald, *The Bitter Harvest of War: New Brunswick and the Conscription Crisis of 1917* (Fredericton: Goose Lane Editions, 2008), 22.

8. Theobald, *The Bitter Harvest of War*, 14.

9. Theobald, *The Bitter Harvest of War*, 26.

10. Theobald, *The Bitter Harvest of War*, 14.

11. Theobald, *The Bitter Harvest of War*, 37.

12. Theobald, *The Bitter Harvest of War*, 71.

13. Hilary Roberts, "Photography," in *1914-1918-online. International Encyclopedia of the First World War*, eds. Ute Daniel, Peter Gatrell, Oliver Janz, Heather Jones, Jennifer Keene, Alan Kramer, and Bill Nasson. Freie Universität Berlin, October 8, 2014, https://encyclopedia.1914-1918-online.net/article/photography.

14. Roberts, "Photography."

15. Veterans Affairs Canada, "The Last Hundred Days," February 14, 2019, https://www.veterans.gc.ca/eng/remembrance/history/first-world-war/fact_sheets/hundred-days.

16. Desmond Morton and J.L. Granatstein, *Marching to Armageddon: Canadians and the Great War 1914-1919* (Toronto: Lester & Orpen Dennys, 1989), 207.

17. Morton and Granatstein, *Marching to Armageddon*, 218.

18. Tim Cook, *Shock Troops: Canadians Fighting The Great War 1917-1918* (Toronto: Penguin Canada, 2008), 570-71.

19. According to photo archivist Joshua Green, these photos were developed on European paper, indicating they were developed in either France or Belgium and not on the photographer's return to North America. They were likely purchased by Len while he was in France.

20. "Personnel Records of the First World War," Library and Archives Canada, Military Heritage, digitized service file for Leonard O. Keith, RG 150, Accession 1992-93/166, Box 5038 - 31 – 484513, https://www.bac-lac.gc.ca/eng/discover/military-heritage/first-world-war/personnel-records/Pages/item.aspx?IdNumber=484513.

21. 3rd Canadian Infantry Works Company War Diary, RG9-III-D-3 (Volume/box number: 5008. File number: 710. Container: T-10856. File Part 1, March 1919) Library and Archives Canada, 4.

22. "Personnel Records of the First World War" (RG 150, Accession 1992-93/166, Box 1818 - 50 – 107076).

23. Jason Crouthamel, "Sexuality, Sexual Relations, Homosexuality," in *1914-1918-online. International Encyclopedia of the First World War*, ed. Peter Ute Daniel, https://encyclopedia.1914-1918-online.net/pdf/1914-1918-Online-sexuality_sexual_relations_homosexuality-2014-10-08.pdf.

24. Crouthamel, "Sexuality, Sexual Relations, Homosexuality."

25. Crouthamel, "Sexuality, Sexual Relations, Homosexuality."

26. Helmut Kallmann and Edward B. Moogk, "The Dumbells," *The Canadian Encyclopedia, Historica Canada* (August 19, 2007), https://www.thecanadianencyclopedia.ca/en/article/the-dumbells-emc.

27. Crouthamel, "Sexuality, Sexual Relations, Homosexuality."

28. Stephen Bourne, *Fighting Proud: The Untold Story of the Gay Men Who Served in Two World Wars* (London: I.B. Tauris, 2017), 11.

29. Bourne, *Fighting Proud*, 11.

30. Bourne, *Fighting Proud*, xvi.

31. "Courts Martial of the First World War," Library and Archives Canada, *Military Heritage*, digitized records for Emile Charette (RG150 - Ministry of the Overseas Military Forces of Canada, Series 8, File 649-C-32586, Microfilm Reel Number T-8659, Finding Aid Number 150-5, image 4413-4424).

32. "Courts Martial of the First World War," Library and Archives Canada, *Military Heritage*, digitized records for Romeo Belisle (RG150 - Ministry of the Overseas Military Forces of Canada, Series 8, File 649-B-44073, Microfilm Reel Number T-8664, Finding Aid Number 150-5, images 1187-1195).

33. "Courts Martial of the First World War," Library and Archives Canada, *Military Heritage*, digitized

records for Hugh Pope Hennessy (RG150 - Ministry of the Overseas Military Forces of Canada, Series 8, File 649-H-11384, Microfilm Reel Number T-8666, Finding Aid Number 150-5, images 0942-0957).

34. "Courts Martial of the First World War," Library and Archives Canada, *Military Heritage*, digitized

records for Ernest S. Keeling (RG150 - Ministry of the Overseas Military Forces of Canada, Series 8, File 649-K-8962, Microfilm Reel Number T-8669, Finding Aid Number 150-5, images 3956-3986).

35. Paul Jackson, *One of the Boys: Homosexuality in the Military during World War II* (Montreal: McGill-Queen's University Press, 2010), 36.

"A Devil in His Own Home Town"

1. Weston J. Gaul, "They call him the Summertime Santa," *Maclean's*, June 15, 1936, 18.
2. "Welcome Tendered Havelock Soldiers," *Kings County Record*, September 5, 1919, 3.
3. *Saint John Daily Telegraph and Sun*, September 5, 1922.
4. Douglas How, *The 8th Hussars: A History of the Regiment* (New Brunswick: Maritime Publishing, 1964), 380.
5. How, *The 8th Hussars*, 95.
6. Havelock Women's Institute, *Butternut Ridge-Havelock*, 91.
7. "He's A Devil in His Own Home Town," Wikisource, December 21, 2017, https://en.wikisource.org/wiki/He%27s_A_Devil_in_His_Own_Home_Town.
8. B.J. Grant, *When Rum was King* (Fredericton: Goose Lane Editions, 1984), 6.
9. "Havelock," *Kings County Record*, November 1, 1895.
10. Grant, *When Rum was King*, 87.
11. Daniel Francis, "Making Canada Dry," *Canada's History Magazine*, June-July 2020, 24.
12. Grant, *When Rum was King*, 37.
13. Grant, *When Rum was King*, 109.
14. Maine Memory Network, "183-189 Washington Avenue, Portland, 1924," *Maine Historical Society*, https://www.mainememory.net/artifact/84674#image_84674.

15. Scott T. Hanson, "Forrest Avenue and Stevens Avenue Portland, Maine, Historical Context," Sutherland Conservation & Consulting, August 2015, 5.
16. Ian M. Drummond and Gord Mcintosh, "Economic History of Atlantic Canada," in *The Canadian Encyclopedia. Historica Canada* (March 7, 2018), https://www.thecanadianencyclopedia.ca/en/article/economic-history-of-atlantic-canada.
17. *Casco Bay Weekly*, May 23, 1996, 21, https://digitalcommons.portlandlibrary.com/cbw_1996/21.
18. *Portland Maine Directory* (1924). 772; *Portland Maine Directory* (1925), 789.
19. *Moncton Transcript*, May 26, 1924.
20. Len also had two employees, Clarence Fletcher and Clifford Plume, who worked for him and operated the business in his absence. Havelock Women's Institute, *Butternut Ridge-Havelock*, 117.
21. "Havelock Dealer Has Sudden Death," *Telegraph Journal* (Saint John, N.B.), February 16, 1928.
22. Havelock Funeral Home Collection, Provincial Archives of New Brunswick (MC1454/MS2).
23. "Personnel Selection Record," Military Personal File for Joseph Austin Coates, Second World War, ATIP and Personnel Records Office, Library and Archives Canada.

The Outing

1. Personal communication with Kate Baglole, whose grandmother remembered hearing the story as a young girl. David Keirstead, the owner of the Havelock Funeral Home, which was run in the old Keith Home, would often be approached by villagers who shared stories of the Keith Family and referred to Len as a "colourful character."

2. *New Brunswick Fox Ranches-Directory*, York-Sunbury Historical Society Collection, Provincial Archives of New Brunswick (MC300/MS49/205).
3. "Topographical map of the counties of St. John and Kings, New Brunswick," Norman B. Leventhal Map Center Collection, https://collections.leventhalmap.org/search/commonwealth:4m90fg66j.

4. Len's mother, Agnes Keith, was named as owing money to Niles Marr, Percy's father, in the probate documents following Niles's death. Len and his brother Bliss are also recorded as endorsing a note owed by Agnes. The naming of Len in the probate document may provide a clue as to the events surrounding his outing, as does the fact that it is unclear how much money precisely was owed. Perhaps Len was the one in debt to the Marr family, and Percy threatened to expose him as a homosexual. Or the "loan" may have been hush money paid to the Marr family to stop Percy and other family members from talking about Len's outing and spreading more gossip about him.

5. *Burlington Daily News* (Burlington, Vermont), August 15, 1931.

6. Power of Attorney: Leonard O. Keith to Lucy I. Keith, no. 88587, August 15, 1931, State of Vermont, Chittenden County.

7. Alexander, Meem, and Gibson, *Finding Out*, 57. According to EGALE Canada in 2015, 79 percent of trans youth in Canada had been victims of physical assault. In 2019, CBC reported that Stats Canada statistics indicated a 41 percent increase in hate crimes against queer people since 2009.

8. Tyler Cline, "'A Clarion Call To Real Patriots The World Over': The Curious Case of the Ku Klux Klan of Kanada in New Brunswick during the 1920s and 1930s," *Acadiensis* 48, no. 1 (Spring/printemps, 2019): 88-89.

9. Cline, "A Clarion Call," 99.

10. "Women living along lonely road terrorized by actions of vested and hooded men," *The Telegraph Journal* (Saint John, N.B.), August 22, 1928.

11. "Ku Klux Klan has initiation," *Kings County Record*, August 31, 1928.

12. Havelock Women's Institute, *Butternut Ridge-Havelock*, 137.

13. Letter from Sussex merchant to G.E. Davies, Ku Klux Klan of Kanada fonds, Provincial Archives of New Brunswick (MC2604/MS3).

14. Grant, *When Rum Was King*, 43.

15. Rebecca Rose, *Before the Parade: A History of Halifax's Gay, Lesbian, Bisexual Communities, 1972-1984* (Halifax: Nimbus Publishing, 2019), 133.

Life Afterwards

1. Havelock Women's Institute, *Butternut Ridge-Havelock*, 91.

2. "Record of Service," Military Personal File for Joseph Austin Coates, Second World War, ATIP and Personnel Records Office, Library and Archives Canada.

3. Jackson, *One of the Boys*, 35.

4. Jackson, *One of the Boys*, 29.

5. Jackson, *One of the Boys*, 38.

6. Jackson, *One of the Boys*, 28.

7. "Record of Service," Military Personal File for Joseph Austin Coates, Second World War, ATIP and Personnel Records Office, Library and Archives Canada.

8. Jackson, *One of the Boys*, 48.

9. Personal correspondence with Dr. Lee Windsor, November 16, 2020.

10. "Service Interview Summary," Military Personal File for Joseph Austin Coates, Second World War, ATIP and Personnel Records Office, Library and Archives Canada.

11. "Marriage Record, Joseph Austin Coates and Rita Janet Cameron," Provincial Archives of New Brunswick, Fredericton (NB, RS141/B4/1940/18554).

12. "Death Occurs of J.A. Coates," *Moncton Transcript*, October 12, 1965, 13.

13. Personal communication with Ava Dickson, November 2019.

14. "Maritime-bred Pacing Mares: Donna Way Captures Ma Cherie Pace," *Moncton Daily Times*, September 2, 1965.

15. *La Gazette officielle du Québec*, no. 52, 26 décembre 1953, 34.

16. "Deaths," *The Montreal Daily Star*, September 25, 1950, 25.

17. "Mrs. Agnes Keith Dies in Havelock," *The Moncton Transcript*, September 28, 1948, 2.

Preserving Len & Cub

1. Valerie J. Korinek, *Prairie Fairies: A History of Queer Communities in Western Canada, 1930-1985* (Toronto: University of Toronto Press, 2018), 4.

2. Cameron Duder, *Awfully Devoted Women: Lesbian Lives in Canada 1900-1965* (Vancouver: University of British Columbia Press, 2011), 3.

3. Duder, *Awfully Devoted Women*, 36.

Appendix I

1. Tom Hooper, "Canada is releasing a coin commemorating a myth: that homosexuality was decriminalized in 1969," CBC News, April 22 2019, https://www.cbc.ca/news/opinion/canada-coin-1.5100177.

2. Constance Backhouse, "A History of Canadian Sexual Assault Legislation 1900-2000," http://www.constancebackhouse.ca/fileadmin/website/1969.htm#20.

3. Warner, *Never Going Back*, 38.

4. Tom Hooper, Gary Kinsman, and Karen Pearlston, "Anti-69 FAQ," February 14 2019, https://anti-69.ca/faq/#1.

5. Westmorland County Court Records, Provincial Archives of New Brunswick, Fredericton (RS474/1950/71855).

6. Carleton County Court Records (RS462/1961/W-959).

7. Carleton County Court Records (RS462/1962/W-362).

8. Provincial Archives of New Brunswick, Fredericton (RS795/73/0327).

9. Kate Zieman, "Queenie and Ted," in *Any Other Way: How Toronto got Queer*, eds. Stephanie Chambers et al. (Toronto: Coach House Press, 2017), 116-17. Special thanks to Isobel Carnegie for alerting the authors to Ted and Queenie's story.

10. Conor Falvey, "Foregrounds: Mapping Gay, Lesbian & Bisexual History in Fredericton, 1969-1999," MA thesis (University of New Brunswick, 2015), 69.

11. Falvey, "Foregrounds," 71.

12. Falvey, "Foregrounds," 84.

13. Anthony Lister, Hank Williams, David Ng, Francis Young, and David Underhill (former members of Fredericton Lesbians and Gays), interview by Dusty Green, September 20, 2017.

14. Falvey, "Foregrounds," 63.

15. City of Moncton Records, Provincial Archives of New Brunswick, Fredericton (RS418 Community Services- Gays in the Park /1981).

16. "Picnic slated," *Moncton Transcript*, June 27, 1981, 33.

17. "Boycott urged after city council move," *Moncton Transcript*, June 30, 1981, 1.

18. Falvey, "Foregrounds," 99.

19. Falvey, "Foregrounds," 115.

20. Falvey, "Foregrounds," 56-58.

21. CBC News-New Brunswick, "36 senators sign letter in support of Clinic 554," September 30, 2020, https://www.cbc.ca/news/canada/new-brunswick/clinic-554-senators-letter-support-abortion-new-brunswick-1.5744390.

22. Julia Wright, "'Like a double agent': A Saint Johner's fight against conversion therapy," CBC News-New Brunswick, January 6, 2020, https://www.cbc.ca/news/canada/new-brunswick/gay-conversion-therapy-lgbtq-new-brunswick-saint-john-pride-1.5410153.

Appendix II

1. Rose, *Before the Parade*, 112.

MEREDITH J. BATT (they/them) grew up in Sackville/Moncton and earned a BA in history at the Université de Moncton. They currently work as an archivist at the Provincial Archives of New Brunswick in Fredericton. Their writing has appeared in *Xtra Magazine*, the *Canadian Historical Review*, and *Active History*.

DUSTY GREEN (he/they) grew up in northwest New Brunswick and holds degrees from St. Thomas University and the New Brunswick College of Craft and Design. Green has previously worked at the New Brunswick Provincial Archives and Fredericton Region Museum. He is currently manager of communications and marketing at the New Brunswick Lung Association. While working at the Provincial Archives, Green came across the photos of Len and Cub and created a photo book that would be the precursor of *Len & Cub: A Queer History*.

Green founded the Queer Heritage Initiative of New Brunswick (QHINB) in 2016, with Batt joining in 2018 and currently serving as president. QHINB is an archival and educational initiative that aims to collect and preserve archival records of 2SLGBTQ+ history in the province. Since then, Batt and Green have conducted oral history interviews and worked with numerous 2SLGBTQ+ individuals and organizations to ensure that New Brunswick's queer history has a permanent home in the Provincial Archives.